NORMAN BEL GEDDES

From Horizons to the Futurama

NORMAN BEL GEDDES

From Horizons to the Futurama

JAMES LONGFORD

SOUTHGATE BOOKS

First published by Southgate Books, London, 2019.

www.southgatebooks.com

Copyright © James Longford 2019

The right of James Longford to be identified as the author of this work has been asserted by him in accordance with the Copyright, Designs and Patents Act 1988. All rights reserved. No part of this publication may be reproduced, stored in a retrieval system or transmitted in any form without the prior permission in writing of the publisher.

This book is sold subject to the condition that it shall not, by way of trade or otherwise, be lent, re-sold, hired out, or otherwise circulated without the publisher's prior consent in any form of binding or cover other than that in which it is published and without a similar condition including this condition being imposed on the subsequent purchaser.

ISBN-13: 978-1-688-99381-5

The notes and bibliography in this work follow the Modern Humanities Research Association (MHRA) system.

Cover illustration: Futurama ride and diorama, c. 1939. Photographer unknown. New York Public Library.

Contents

List of illustrations

Acknowledgements

1	Introduction	1
2	Norman Bel Geddes	3
3	Consumer Engineering	4
4	*Horizons*	5
5	Streamlining and Eugenics	8
6	Stoves and Ocean Liners	10
7	Chicago World's Fair	20
8	Shell Oil City of Tomorrow	31
9	Futurama	38
10	Conclusion	49
	Bibliography	51

List of illustrations

1	*Horizons* cover	2
2	Acorn gas stove	11
3	Vulcan gas range	12
4	Wooden blocks for the Oriole stove	13
5	Airliner Number 4 newspaper article	15
6	Ocean Liner patent application	16
7	'The Principle of Streamlining'	17
8	*Popular Science Monthly*, April 1934	19
9	*Popular Mechanics Magazine*, July 1930	21
10	El Lissitzky *Wolkenbügel*	22
11	Theater Number Fourteen	24
12	Repertory Theatre	25
13	Temple of Music	26
14	Theater Number Fourteen	27
15	Theater Number Six	28
16	Burlington Zephyr	30
17	Electrolux vacuum cleaner	31
18	The City of Tomorrow	33
19	Hugh Ferriss, *Skyscraper Hangar*	37

20	Highways & Horizons model	39
21	Highways & Horizons illustration	40
22	Highways & Horizons building front	41
23	Highways & Horizons cut-away	43
24	Futurama ride	44
25	Aerial view of Futurama model	45
26	Futurama intersection	47

Acknowledgements

I would like to thank the academic staff and librarians of the University of London's many colleges and libraries for their assistance with this work, particularly Birkbeck College, Senate House Library, and University College Library. Thank you also to those who supplied photographs whose copyright is acknowledged where applicable and to those who commented on the draft and helped to correct errors. Any remaining errors are my responsibility.

1 Introduction

HORIZONS

A GLIMPSE

into the

NOT FAR-DISTANT FUTURE, a future that will see many if not all of our present notions of form cast into the discard—when, through the influence of new design, most of the features of our everyday life will take on new aspects for the greater economy, efficiency, comfort and happiness of our lives.[1]

Norman Bel Geddes's design for the Futurama at the 1939 New York World's Fair was probably the high point of his design career. Completed just before the outbreak of the Second World War in Europe its optimistic vision seems to neatly book-end a period that began in the early 1930s when Geddes published *Horizons* (Figure 1) and America began the fight to shake off the effects of the Wall Street Crash and ensuing Great Depression. The period was a notably creative one for Geddes even though many of his ideas never came to fruition at the time, and one that provides not only an interesting case study of one designer's work but also the opportunity to explore a number of wider themes.

This book will examine the rise of Geddes as an industrial designer in the inter-war years against the background of the Depression and an increased awareness of the importance of design in selling products. It will then go on to discuss *Horizons* and its role in promoting Geddes's career and in popularising streamlining, together with the connections between streamlining and the eugenics movement. I will then discuss

[1] Norman Bel Geddes, *Horizons* (Boston: Little, Brown, 1932), dust jacket.

some of the consumer, transportation, and architectural projects described in the book and look at what they tell us about Geddes's working methods and the streamlined aesthetic in practice. The Shell Oil City of Tomorrow will be examined in the context of Geddes's self-image as a visionary which will be combined with a discussion of the aerial view and the role of the urban planner. Finally, I will examine the Futurama project by which time Geddes had moved from designing individual products and buildings under the influence of the streamlined aesthetic and architectural modernism, to designing whole utopian worlds with an authority characteristic of the visionary planner and by when streamlining had come to mean much more than simply aerodynamics.

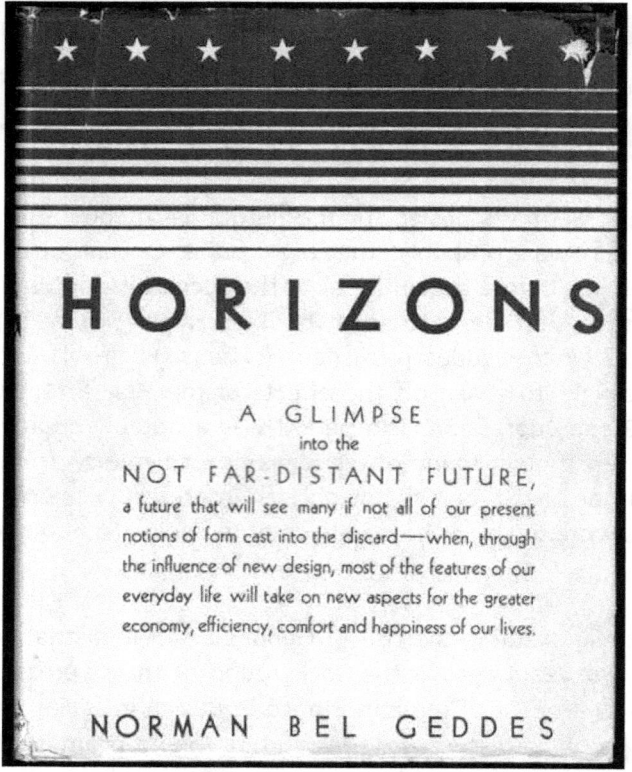

Figure 1. *Horizons* cover, 1932.

2 Norman Bel Geddes

Norman Bel Geddes (1893-1958) was a man of restless ingenuity. Until his early 30s he worked almost solely in the theatre designing sets, lighting effects, audio equipment and complete theatres. He developed the first 'diagonal axis' theatre layout in 1915 and his designs were exhibited at the Art Institute of Chicago and the Victoria and Albert Museum.

He did not, however, show any engagement with consumer goods, transportation design, or non-theatrical architecture until after 1926 when he spent the weekend at the home of Ray Graham of the Graham-Paige Motor Company. During the course of the weekend, according to B. Alexandra Szerlip, Graham asked Geddes if he had ever considered turning his design skills to the improvement of everyday objects? Geddes recalled later, 'Something sent the blood rushing through me, [...] I didn't glow; I burned all over.'[2] He soon had a contract to design a car that was guaranteed not to go out of style for five years.[3] In 1927, he announced his move into the emerging field of industrial design.

Geddes was one of the first of the industrial designers in the sense of independent contractors operating their own businesses who obtained commissions from manufacturers and other commercial clients to design or re-design their goods. The other main names were Raymond Loewy, Walter Dorwin Teague and Henry Dreyfuss. They were centred in New York, not coincidentally also the centre of the advertising industry, and often had backgrounds in illustration or theatre design.[4]

[2] B. Alexandra Szerlip, *The Man Who Designed the Future: Norman Bel Geddes and the Invention of Twentieth-Century America* (Brooklyn: Melville House, 2017), p. 115.
[3] Norman Bel Geddes, *Miracle in the Evening: An Autobiography*, ed. by William Kelley (Garden City, NY: Doubleday, 1960), p. 344.
[4] Regina Lee Blaszczyk, 'Imagining Consumers: Norman Bel Geddes and American Consumer Culture', *in Norman Bel Geddes Designs America*, ed. by Donald Albrecht (New York: Abrams, 2012), pp. 70-93 (p. 74).

Timeline

1893	Norman Bel Geddes born
1927	Geddes moves into industrial design
1929	Christine Frederick's *Selling Mrs. Consumer* published
1929	Geddes appointed 'dramatization expert' for Chicago World's Fair
1931/32	Oriole gas stove designed
1932	Streamlined Ocean Liner designed
1932	*Horizons* published
1933/34	Chicago World's Fair
1934	Burlington Zephyr designed by E.G. Budd company
1934/35	Electrolux vacuum designed
1936	Shell Oil City of Tomorrow designed
1938	General Motors Highways and Horizons building designed
1939/40	New York World's Fair
1940	*Magic Motorways* published
1958	Norman Bel Geddes dies

3 Consumer Engineering

Geddes's move out of theatre came at a time when design was beginning to be taken more seriously by the manufacturers of goods. In a prescient article in *Atlantic Monthly* in 1927, 'Beauty the New Business Tool', that anticipated the era of mass consumption and planned obsolescence, advertising pioneer Earnest Elmo Calkins argued that beauty and style had entered the realm of product design because 'the appeal of efficiency alone is nearly ended. Beauty is the natural and logical next step', he said, giving the example of how the Chevrolet company had overtaken Ford by adding the colour and design to their products that Ford had eschewed. According to Calkins, adding beauty to utility could persuade people to replace objects that in fact continued to function perfectly well.[5]

[5] Earnest Elmo Calkins, 'Beauty the New Business Tool', *Atlantic Monthly*, August 1927, 145-156 <https://www.theatlantic.com/magazine/archive/1927/08/beauty-the-new-business-tool/376227> [accessed 19 February 2018].

The idea was expanded upon in Roy Sheldon and Egmont Arens's influential 1932 book *Consumer Engineering: A New Technique for Prosperity* (Harper and Brothers, New York) while the home economist and advocate of streamlined Taylorist efficiency, Christine Frederick, argued in *Selling Mrs. Consumer* (1929) for the advantages of 'progressive obsolescence' in consumer goods in order to create jobs and prosperity.[6]

In 1934, *Fortune* magazine described how appearance was being used to sell products in the 'formerly artless industries' such as the manufacture of sewing machines and electrical appliances where previously utility had been the only selling point.[7] American companies, converted to the selling power of good design and trying to shake off the Depression, increasingly marketed their products at decade's regional and World's Fairs.[8] All these factors created a positive background for Geddes's burgeoning industrial design career but also suggested some of the criticism that would later be made of the streamlining he advocated in his work.

4 *Horizons*

The most comprehensive statement of Norman Bel Geddes's philosophy was his 1932 book *Horizons* which also doubled as a marketing brochure for future work and the equivalent of an artist's manifesto. He was the first of the new industrial designers to publish such a work.[9] In it he reprised his successful completed work since 1927, which was relatively modest, as well as the numerous uncompleted or speculative projects, often much larger than the realised ones, which he had developed. He also integrated these projects into his overall design philosophy and

[6] Christine Frederick, *Selling Mrs. Consumer* (New York: Business Bourse, 1929), p. 245.
[7] Carma R. Gorman, 'Educating the Eye: Body Mechanics and Streamlining in the United States, 1925-1950', *American Quarterly*, 58 (2006), 839-68 (p. 839).
[8] Roland Marchand, 'The Designers go to the Fair, II: Norman Bel Geddes, The General Motors "Futurama", and the Visit to the Factory Transformed', in *Design History: An Anthology*, ed. by Dennis P. Doordan (Cambridge, MA: MIT Press, 1995), pp. 103-21 (p. 103).
[9] Nicolas P. Maffei, *Norman Bel Geddes: American Design Visionary* (London: Bloomsbury Academic, 2018), p. 57.

vision of the future. The fantastic nature of some of his ideas chimed with the tone of popular science fiction illustration and designs from the book subsequently appeared in popular non-fiction science magazines such as *Popular Mechanics Magazine* and *Popular Science Monthly*.[10]

Geddes opened the book with the words, 'We enter a new era'. He wrote that there was something special about the 1930s; a period, he thought, in which life was moving more urgently than ever before and one in which, despite economic depression, or perhaps because of it, a new age was dawning with 'invigorating conceptions and the horizon lifted'.[11] His optimistic reaction to the challenges of the depression was partly a result of his mother's faith in Christian Science with its belief in the power of the mind to overcome matter, but it also reflected his personal ambition, fertile imagination, and inherent showmanship.[12]

For Geddes, the future was arriving soon, and his was a utopian rather than a dystopian vision.[13] Many of the projects he described in *Horizons* seem notably ambitious both technically and against the background of Depression era America, but Geddes never conceded that any of his ideas were unfeasible despite the criticism on that score that he faced during his lifetime, and this is reflected in the detailed schematics and technical specifications that he included in the book.

The shape of the future was streamlined. Not just for the functional reasons described by Geddes in *Horizons* that related to the need for objects to move through space with the minimum of air resistance which had been written about since the turn of the twentieth century and known about intuitively in water craft since antiquity, but because things looked more up-to-date when streamlined.[14] And as Calkins had noted, if things looked more modern they were also more saleable and made competitors' products seem obsolete.[15]

[10] Maffei, p. 58.
[11] Geddes, *Horizons*, pp. 3-4.
[12] Donald Albrecht, 'Introduction', in *Norman Bel Geddes Designs America*, ed. by Donald Albrecht (New York: Abrams, 2012), pp. 11-53 (pp. 11-12).
[13] Albrecht, p. 12.
[14] David A. Hanks and Anne Hoy, *American Streamlined Design: The World of Tomorrow* (Paris: Flammarion, 2005), p. 17.
[15] Calkins, pp. 145-156.

The technology of the age wasn't necessarily that new, but in streamlined form it nonetheless came to stand for modernity in the 1930s, even in static or inactive technology such as the developing mass market for electric consumer products.[16] In 1917, just 24% of American homes had been supplied with electricity, but by 1940 that was nearly 90%.[17] The radio set was a prime example of a new and fast developing but immobile technology that Calkins described in 1927 as having been 'put in the hands of the designers, to make it, if possible, a thing of beauty and a joy forever even when silent or especially when silent'.[18] In this way, design could give objects an additional and aesthetic function even when inactive, as streamlining did for many static objects in the 1930s.

In addition to streamlining's ability to make the old look new, the new look newer, and the static look dynamic, it tended to romanticise technology by shifting the emphasis from the technical and mechanical to the exterior form. Objects whose appeal had previously been based on what they could do, now appealed for how they looked and became symbols of wealth and personal sophistication.[19] Streamlining thus had a therapeutic function in reducing anxiety about technology that Paul T. Frankl identified in 1928 when he described the simpler lines of modern design as tending 'to cover up the complexity of the machine age. If they do not completely do this, they at least divert our attention and allow us to feel ourselves master of the machine.'[20]

Streamlining had a particular appeal in America in the 1930s. In goods for the home it was fairly democratic; you didn't have to be wealthy or cultured to participate, making it a style that could be enjoyed by the masses, even if the purchase of new electrical goods was mostly restricted to the middle classes who could afford to buy new. And in its obsession with speed, it expressed what the designer Egmont Arens described as 'this particular genius of the American people to be going

[16] Hanks and Hoy, p. 18.
[17] Victor Margolin, *World History of Design: Volume 2 World War I to World War II* (London: Bloomsbury Academic, 2015), p. 367.
[18] Calkins, pp. 145-156; Hanks and Hoy, pp. 17-18.
[19] Catherine McDermott, *Design: The Key Concepts* (Abingdon: Routledge, 2007), pp. 153-54 & 211-12; Albrecht, p. 17.
[20] Paul T. Frankl, *New Dimensions: The Decorative Arts of Today in Words & Pictures* (New York: Payson & Clarke, 1928), p. 17.

places-and be going there fast'.[21] In addition, it was natively American, perhaps even the 'first all-American aesthetic'.[22] As far back as 1908, Adolf Loos, who advocated the removal of ornamentation, had lamented the aesthetic backwardness of some in Europe, saying 'Happy the land that has no such stragglers [...] Happy America!'[23] And when the National Alliance of Art and Industry staged its annual show in 1934 it announced it with the mission 'To Celebrate the Emergence of an American Style'.[24]

5 Streamlining and Eugenics

From the start, streamlining had been in debt to the ideas of Adolf Loos who in 1908 had argued that ornament was produced by criminals and the uncivilised and connected the evolution of higher forms of culture to the progressive removal of ornament. Those who still liked ornament, he said, were the 'stragglers' who slowed down 'the cultural evolution of the nations and of mankind'.[25] The implication, not stated explicitly in Loos's essay, was that the path to higher forms of culture lay with the elimination not just of ornament but of the criminals and stragglers who produced it. This had clear parallels with the objective of the Eugenicists in the early twentieth century of improving humanity through the removal of the delinquent and the retrograde.

Christina Cogdell has argued that streamlining, with its emphasis on simple lines, efficiency, speed, the removal of ornamentation, and the elimination of dirt traps was an aesthetic parallel for and was informed by eugenic theory that sought to improve the quality of human stock by improvements from the inside out, just as architects and industrial designers created forms that expressed the inner function on the

[21] Jeffrey L. Meikle, *Twentieth Century Limited: Industrial Design in America, 1925-1939* (Philadelphia: Temple University Press, 1979), p. 165.
[22] Szerlip, p. 150.
[23] Adolf Loos, 'Ornament and crime', in *Programs and Manifestoes on 20th-Century Architecture*, ed. by Ulrich Conrads, trans. by Michael Bullock (Cambridge, MA: MIT Press, 1970), pp. 19-24 (p. 21).
[24] Bevis Hillier and Kate McIntyre, *The Style of the Century*, 2nd edn (New York: Watson-Guptill, 1998), pp. 107-08.
[25] Loos, p. 21.

outside.[26] According to Cogdell, eugenicists had a deliberate policy in the 1930s of pursuing their objectives indirectly. Not because they were self-conscious about the parallels with fascist ideas, that didn't become a problem for them until later, but because topics such as reproduction and sterilisation were not considered polite topics for discussion and might be censored. Instead they juxtaposed the streamlined machine with the streamlined body.[27]

The primary objective of the eugenicists was to improve the human but the non-human body often provided the best exposition of Eugenicist ideas and could be used without the complications that came with human examples. In the mid-1930s, the designer Egmont Arens lectured on 'Streamlining in Nature' featuring examples from animal breeding such as the greyhound to demonstrate how human intervention could create a 'purebreed'.[28] According to Cogdell, Norman Bel Geddes had over forty books on animal breeding, his favourite being *The Basis of Breeding* by Leon Whitney which was published by the American Eugenics Society in 1928. He also maintained a strong interest throughout his life in the mating habits of small animals and kept and studied over one hundred species.[29]

Geddes was not a eugenicist, however, there is strong evidence for the influence of eugenicist and evolutionary ideas on mainstream culture in America before the Second World War that Geddes as an intelligent man with an established interest in animal breeding could not have helped but absorb to some extent. For instance, in an otherwise highly technical piece in 1934, Geddes described the air resistance that streamlining sought to minimise as 'parasite drag', a phrase he may have coined.[30] The titles in his extensive library, documented in many sources, provide additional evidence for his interest in these areas.

While Cogdell argues for the influence of eugenic and evolutionary theory on the aesthetic objectives of streamlining to bring forms 'into

[26] Christina Cogdell, 'The Futurama Recontextualized: Norman Bel Geddes's Eugenic "World of Tomorrow"', *American Quarterly*, 52 (2000), 193-236 (p. 194).
[27] Cogdell, p. 234.
[28] Cogdell, p. 195.
[29] Cogdell, pp. 205-06.
[30] Norman Bel Geddes, 'Streamlining', in *The Industrial Design Reader*, ed. by Carma Gorman (New York: Allworth Press, 2003), pp. 135-39 (p. 136).

conformity with the biological evolutionary laws of nature', Carma R. Gorman has argued for the influence of the 'body mechanics' movement in America on the forming of the taste of the middle classes who were the main market for the sale of streamlined goods.[31] Body mechanics emphasised good posture and the understanding of the body as a mechanism but its emphasis on tautness and leanness, however, was contrary to some of the forms derived from nature that were part of the corpus of streamlined shapes such as Geddes's teardrop shaped cars. His competitor Raymond Loewy once referred to shapes of that kind as 'jelly mould' design, and other designers more closely identified streamlining with sleekness, indicating, as Geddes later acknowledged, that whatever its original scientific basis, streamlining was primarily an aesthetic or styling choice that had a variety of interpretations.[32]

6 Stoves and Ocean Liners

Geddes's designs in *Horizons* were often highly novel with little reference to history except in so far as shapes were intuitively known to be the correct solution to a problem such as the streamlined hull of a ship.[33] Perhaps for that reason, most were never realised such as the giant Air Liner Number 4 (1929), the streamlined Locomotive Number 1 (1931) and the teardrop shaped vehicles that exemplified the transfer of nature's natural streamlining of water under the action of gravity and air into man-made objects.[34]

An exception was his design for the Oriole stove for the Standard Gas Equipment Corporation (SGE) (c. 1931) and the closely related Acorn stove (c. 1932-33, Figure 2) for the Philadelphia Gas Works Company that are good examples of the Geddes design method. Both today look mundane because their basic shape is so familiar but in their day they were radically different to the typical cast-iron stove made in the United

[31] Cogdell, p. 195; Gorman, pp. 857-58.
[32] Gorman, pp. 840 & 857-58.
[33] Margolin, p. 389.
[34] Geddes, *Horizons*, pp. 110 & 69.

States such as the SGE's 1911 Vulcan gas range (Figure 3) that Geddes used for contrast in *Horizons*.[35]

Figure 2. Illustration from Philadelphia Gas Works Company brochure for the Acorn gas stove, c. 1932-33. Artist unknown. Source: Blaszczyk, p. 72.

[35] Geddes, *Horizons*, pp. 249-58.

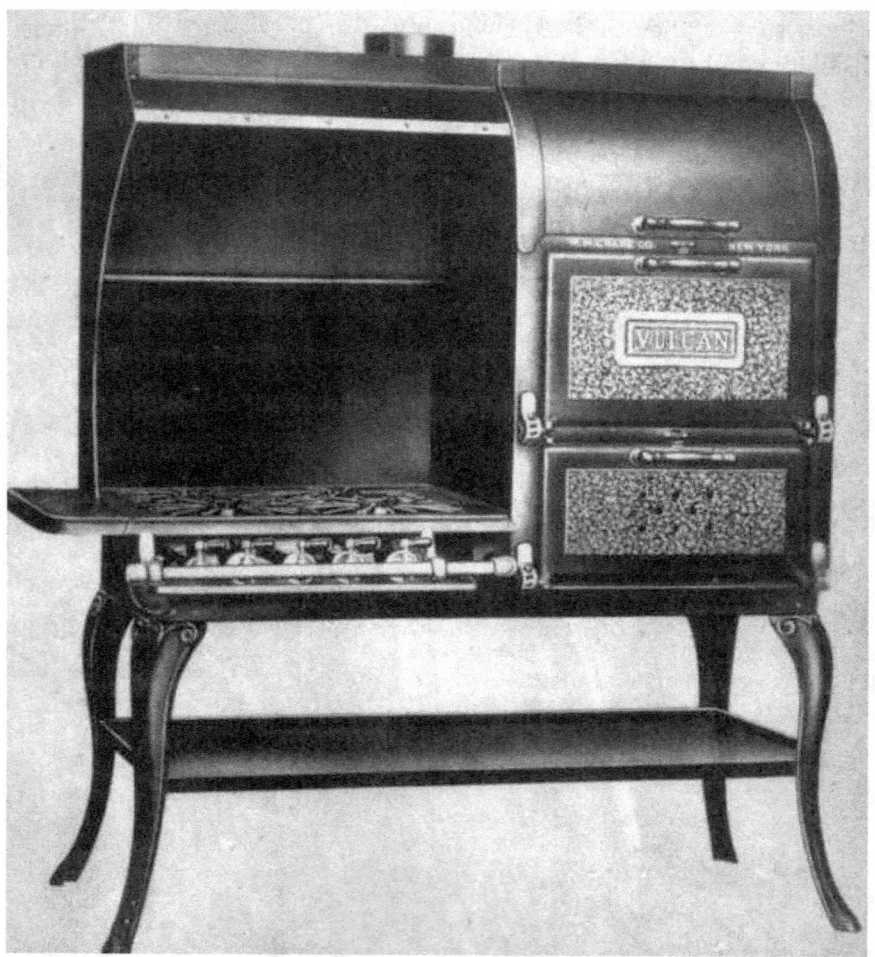

Figure 3. Vulcan gas range, Standard Gas Equipment Corporation. Designed by W.M. Crane Co., 1911. Source: *Horizons*, p. 249.

Geddes and his employees carried out detailed research to come up with the design, starting with a survey of 1,200 stove-users.[36] They discovered that the company was making around 100 different models made up of several hundred different units such as ovens and broilers. The almost all iron construction was hard to keep clean and, being usually black, did not fit with other kitchen units which were usually

[36] Meikle, *Twentieth Century Limited*, p. 101.

white or ivory. There were many other practical disadvantages with the current stoves. Geddes designed a system of wooden blocks (Figure 4) which he combined in different ways in order to rationalise the company's product range down to four models which could be made with twelve standard units.[37] The method used was informed by his experience in designing modular theatre sets which was so innovative that it was featured in *Scientific American* in 1928.[38]

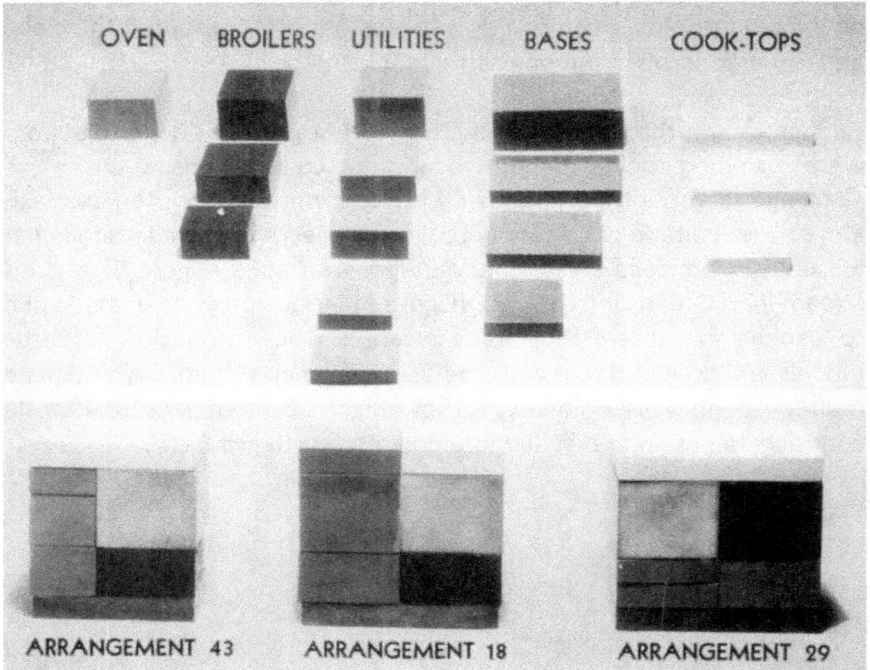

Figure 4. Wooden blocks used to design the Oriole gas stove, 1931.
Source: *Horizons*, p. 254.

The final design replaced iron with sheet metal hung on a steel frame, an innovation made possible by the development of cheap sheet metal for the automobile industry that then found its way into other products and which Geddes compared to skyscraper construction. The old cast

[37] Geddes, *Horizons*, pp. 249-58.
[38] Christopher Innes, 'Modular and Mobile', in *Norman Bel Geddes Designs America*, ed. by Donald Albrecht (New York: Abrams, 2012), pp. 200-13 (p. 207).

iron was replaced with a plain design that went all the way down to the floor with rounded corners that removed all the dirt traps that had plagued the existing models in a style of simplified design that was described by Henry Dreyfuss as 'cleanlining'.[39] It was all-white as white was associated with hygiene, thus presaging the dominance of white in domestic appliances in the rest of the twentieth century.[40] The stove demonstrated a number of themes within Geddes's practice; a lack of reverence for existing forms and the willingness to start from scratch, meticulous research, modularity, a new method of construction using new materials, and a completely new aesthetic that adopted the clean and rounded forms common in streamlining.

Geddes was in the habit of giving his staff large ambitious projects to work on when they were between client commissions, such as the challenge to get 'a thousand luxury lovers from New York to Paris fast. Forget the limitations.'[41] Two unrealised projects with that stamp that featured in *Horizons* are Airliner Number 4 of 1929 (Figure 5) and his streamlined Ocean Liner of 1932 (Figure 6).[42] Such projects enabled him to explore his interest in transportation while producing fantastic models and drawings that could be used to generate publicity and build his reputation as a visionary.[43] They might also generate real world contracts to design or restyle more down-to-earth products.

[39] Christopher Innes, *Designing Modern America: Broadway to Main Street* (New Haven: Yale University Press, 2005), p. 249; Margolin, p. 390.
[40] Szerlip, pp. 153-57.
[41] Donald J. Bush, *The Streamlined Decade* (New York: George Braziller, 1975), p. 27; Szerlip, p. 215.
[42] Geddes, *Horizons*, pp. 38-43 & 109-121.
[43] Albrecht, p. 21.

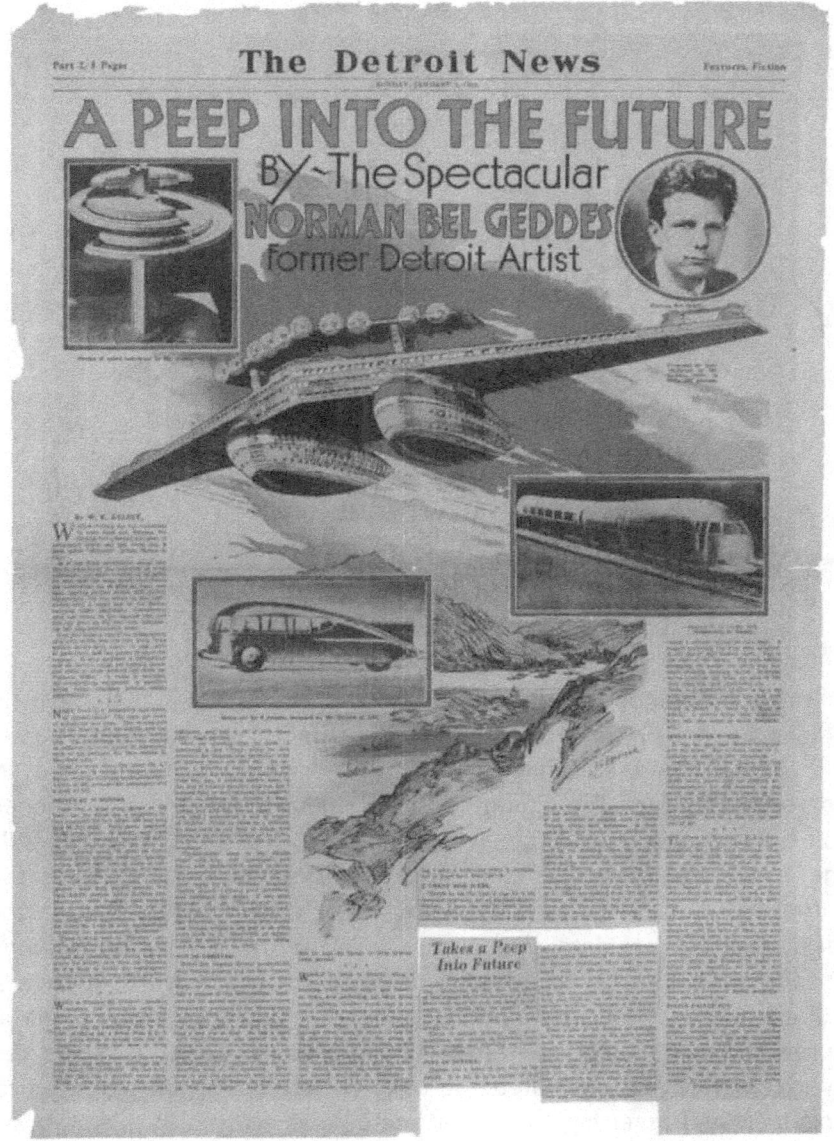

Figure 5. Airliner Number 4 in 'A Peep Into The Future by The Spectacular Norman Bel Geddes Former Detroit Artist' by W. K. Kelsey. *The Detroit News,* 1 January 1933. Artist: J. L. Kraemer.

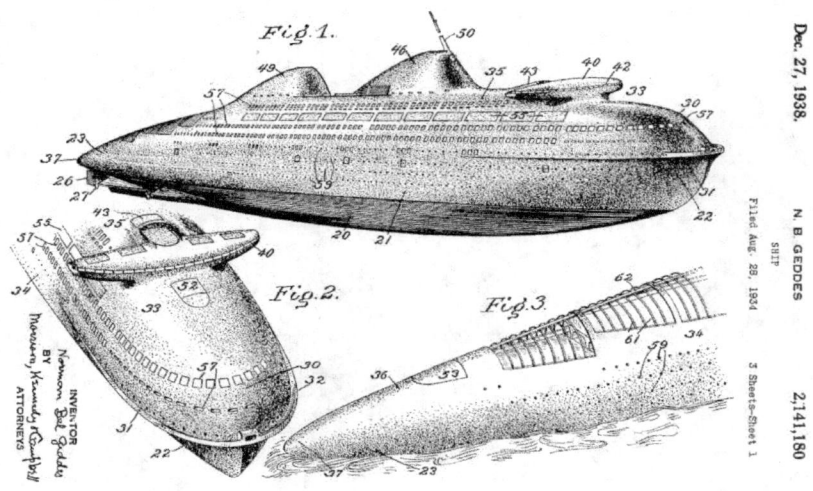

Figure 6. Ocean Liner patent application drawing. Designed by Norman Bel Geddes, 1932. Filed 1934. Source: United States Patent US2141180A, 1938, p. 1.

Of the two, Airliner Number 4, despite its futuristic design that seems to belong to an early science fiction film, seems to have dated more than his design for a streamlined Ocean Liner which has retained its contemporary feel. The aircraft, an amphibious monoplane, is intended to be propeller driven as the jet engine had not yet been invented while the liner's steam power and smoke stacks are hidden inside the smoothed superstructure. Geddes devoted pages in *Horizons* to the facilities, technical details, and economics of the airliner project and despite its ambitious nature, of which Geddes must have been aware, there is no sense anywhere in his writing that he viewed the project as unrealistic.[44] On the contrary, he claimed a scientific basis for everything, having consulted, he said, a noted German aeronautical engineer, and asserting that 'every detail and every principle involved has been tested in one form or another. It is merely the combination that is new.'[45] The self-confidence and assertion of the practicality of the near-fantastic was typical of his methods.

[44] Geddes, *Horizons*, pp. 111-21.
[45] Geddes, *Horizons*, p. 121.

Geddes began his discussion of his Ocean Liner by complaining about the adulteration by French and German shipping lines of what he saw as a naturally elegant form by the addition of decorative detail reminiscent of the excesses of the Victorian era by those that 'depend on ornament to solve any problem.'[46] He thought they imagined they were employing modern principles of design but failed to understand that the true spirit of modern design was to respect functional requirements and to remove the inessential.[47]

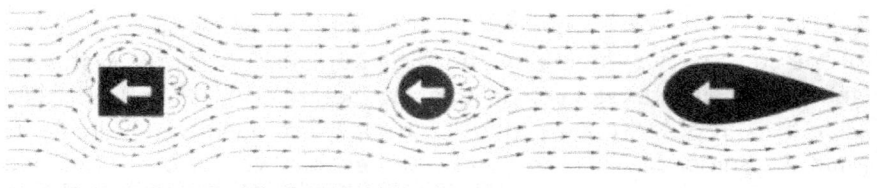

Figure 7. Diagram Illustrating the Principle of Streamlining. Artist unknown. Source: *Horizons*, 1932, p. 45.

For Geddes, every object had an ideal form and once it had evolved into that form it would of necessity be beautiful and wouldn't need any adornment to make it more beautiful, in fact such adornment would degrade it. In this respect, Geddes was expressing views derived from the ideas of Adolf Loos who had argued in his influential 1908 essay 'Ornament and Crime' that the progressive removal of ornament was synonymous with advances in civilisation and its presence evidence of primitivism.[48] By way of example, Geddes cited the swordfish and the seagull, the Arab stallion and the Durham bull. In the case of objects moving through air or water, he thought the natural shape was the teardrop shape with a blunt nose and tapered tail that minimised the eddies that caused disturbances in the elements through which the form moved (Figure 7).[49]

[46] Geddes, *Horizons*, p. 36.
[47] Geddes, *Horizons*, pp. 35-37.
[48] Loos, p. 10.
[49] Geddes, *Horizons*, p. 50.

Although such ideas about streamlining were not new, Le Corbusier had discussed them and illustrated them in the 1927 edition of *Towards a New Architecture*, Geddes does seem to have made personal investigations of the subject, including constructing a 'crude wind tunnel' on the roof of his house in which to experiment with different shapes.[50] Without scientific qualifications, however, the basis for his belief in the efficacy of the tear-drop shape may be as much based on its aesthetic appeal as on its actual efficiency and it is notable that it is not a shape commonly seen in today's motor vehicles.

Geddes's design for the Ocean Liner enclosed the whole superstructure of the ship so that the minimum of the structure above the waterline generated wind resistance. Lightweight metal and glass panels would slide back in order to allow the ship to be more open to the elements than a traditional design in good weather, but when closed, the ship was 'as enclosed as a submarine' and suffered the minimum of wind resistance. The only protruding elements were the streamlined smokestacks and the cantilevered bridge shaped in the form of a monoplane wing (Figure 8) for minimum air resistance.[51] The form of the craft bore a striking resemblance to a dolphin or porpoise with its blunt nose and tapered tail that was the appropriate natural organic form of an object that belonged in the water. With the enclosed upper side, the vessel was now as streamlined above the water as ships had always been below the water. The narrator of a 1935 Pathé newsreel agreed, saying 'nature evolved this form a long time ago'.[52]

[50] Maffei, pp. 108-09.
[51] Geddes, *Horizons*, pp. 38-43.
[52] 'The Liner of Tomorrow!', Pathe Pictorial, 7 March 1935 <https://www.britishpathe.com/video/the-liner-of-tomorrow/> [accessed 9 March 2018]

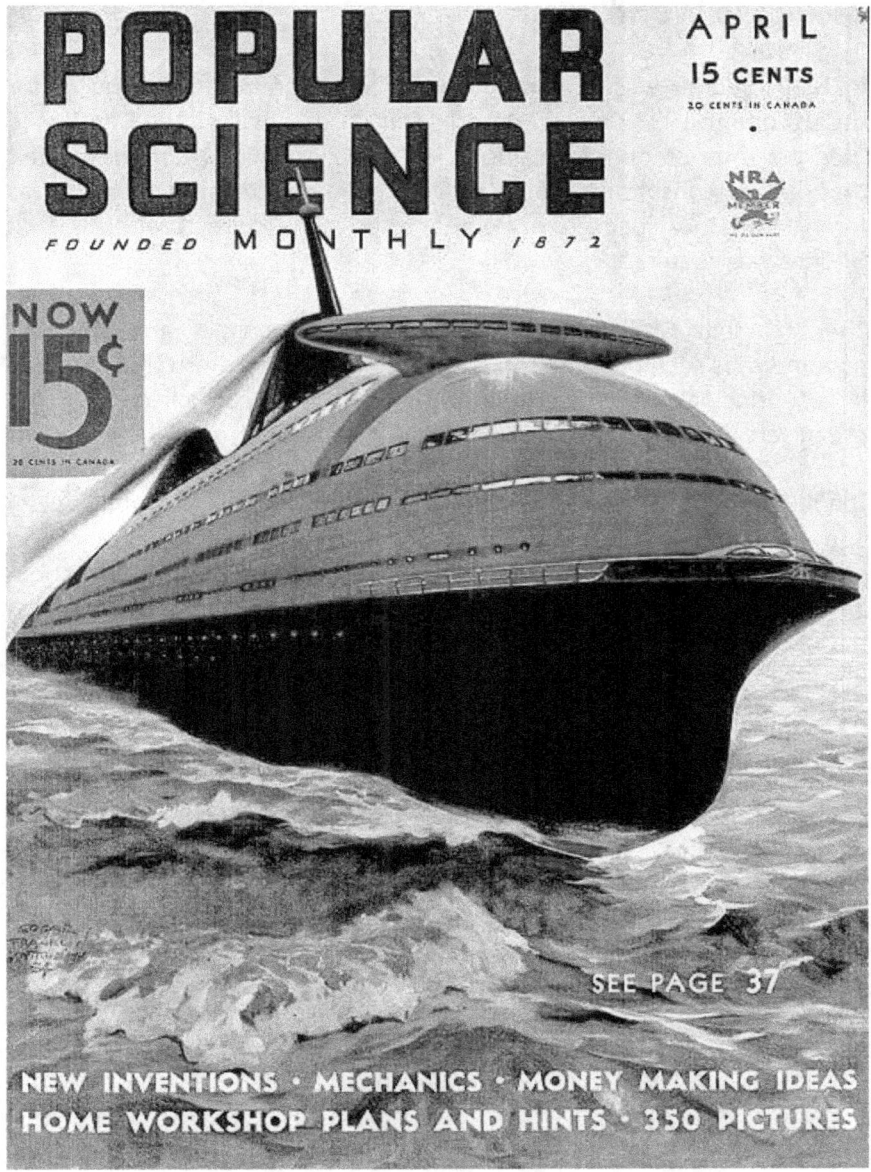

Figure 8. *Popular Science Monthly,* April 1934. Artist: Edgar Franklin Wittmack.

7 Chicago World's Fair

In 1929, Geddes was appointed one of the 'dramatization experts' for the upcoming 1933 Chicago World's Fair, also known as the Century of Progress International Exposition. The fair's organising committee felt that outside consultants would enliven the fair's atmosphere and it was for his theatrical background rather than his architectural skills that Geddes was required.[53]

The fact that Geddes was not a qualified architect and was not appointed as such did not stop him from submitting more than a dozen large, principally architectural, designs to the committee. All the organisers actually wanted for the fair was two theatres and a temple of poetry.[54] Nicolas Maffei writes that in his plans, Geddes recorded that the fair should aim to develop 'the qualities of a) Colosalism, b) Novelty and c) Mystery', colosalism [sic] being self-explanatory while novelty and mystery were to be achieved through concealed lighting, reflection, and glass panels, thus showing the influence of Geddes's stage design background where effects were achieved more through atmosphere and temporary means than through permanent architectural decoration.[55]

Typically of Geddes, his designs for the fair, some of which were existing designs he had been working on for years, but none of which were built, were imaginative, on the borders of practicality, paid little attention to cost and had little historical precedent. They also naturally lent themselves to exploitation for publicity purposes in *Horizons* and elsewhere.[56] Perhaps the design that most caught the public's attention was his rotating Aerial Restaurant (c. 1929) which figured prominently in *Horizons* and in an architecturally accurate, but not to scale, rendering on the front of *Popular Mechanics Magazine* in July 1930 (Figure 9).[57]

[53] Lisa D. Schrenk, *Building a Century of Progress: The Architecture of Chicago's 1933 - 34 World's Fair* (Minneapolis: University of Minnesota Press, 2007), p. 199.
[54] Schrenk, pp. 205-06.
[55] Maffei, p. 50.
[56] Schrenk, pp. 199-200.
[57] Maffei, p. 66.

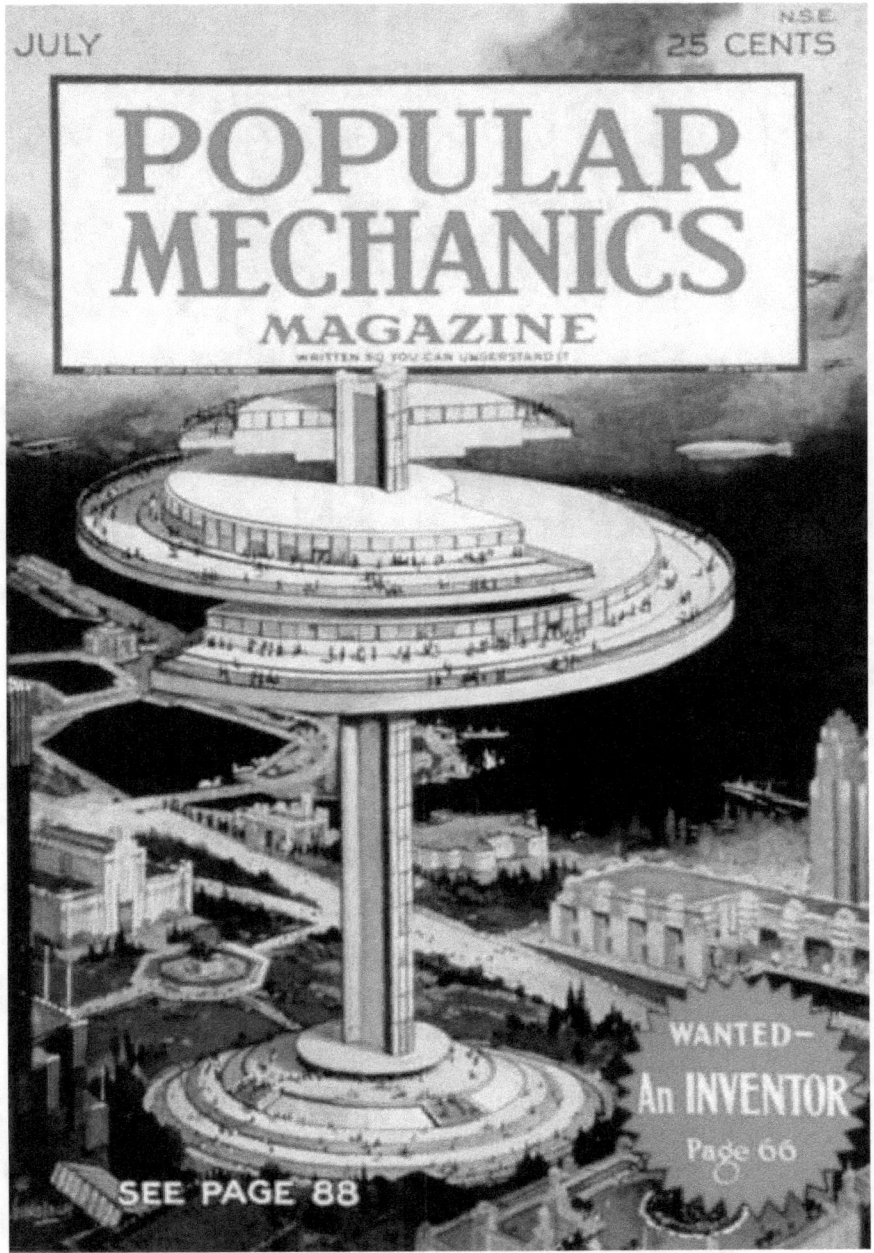

Figure 9. *Popular Mechanics Magazine,* July 1930. Artist unknown.

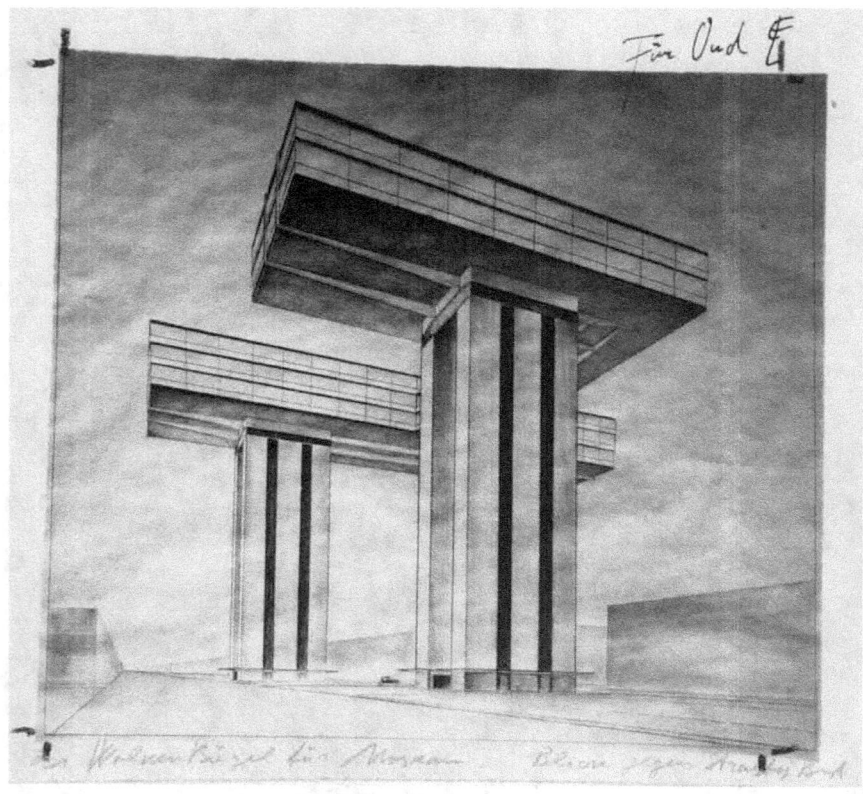

Figure 10. Wolkenbügel on Strastnoy Boulevard in Moscow, El Lissitzky, 1924/25. Location: Van Abbemuseum, Eindhoven.

It may have been influenced by El Lissitzky's 1924/25 horizontal skyscraper, his *Wolkenbügel* (Figure 10). Unlike Lissitzky's design, however, which if it were to expand would do so laterally, Geddes design has vertical momentum. It was intended to be a permanent fixture.[58] Its three elevated tiers afforded diners an ever-changing view of the city of Chicago with each level having a wide veranda on which they could promenade. The semi-circular shape of each tier was explained by the need to balance the rotating load through cantilevering. Geddes explained the elevated height of the structure by the absence of any plot in the main fair grounds large enough to accommodate the normal footprint of a three storey building, saying

[58] Maffei, p. 66.

the base could be built in the courtyard of another building if necessary. A similar rationale to that used by Lissitzky in his design for built-up Moscow.[59]

If built, however, the restaurant would have been an extraordinary and overpowering feat of engineering, and one cannot help but think that overshadowing other buildings at the fair, both literally and metaphorically, would have been one of the principal benefits of the project as far as Geddes was concerned. Even unbuilt, the design still offered tremendous publicity opportunities. The reaction of the critics and qualified architects was mixed with one describing it as 'a little mad' and another complimenting it for boldness, saying it was 'untrammelled by reverence'.[60] Both were correct.

If the restaurant was architecture in the sky, the aerial view of Theater Number Fourteen (1922, Figure 11) gave the impression of a fish or insect moving through water, the head being formed by the tower, the auditorium forming a bulbous body, with a tail and a ripple effect created by the surrounding tiers or steps with the whole also forming a teardrop shape.[61] The similarity was not mentioned in the accompanying text in *Horizons* although an aerial view was used in the book indicating that the effect was probably deliberate.

Geddes also used the teardrop shape in whole or bisected, in his 1929 designs for a Repertory Theater (Figure 12) and four times in his Temple of Music (Figure 13) as part of a fan effect. In an example of form following function, the Repertory Theatre's exterior exactly reveals the inner structure of the theatre with no attempt made at symmetry or to be aesthetically pleasing as he achieved with his Temple of Music.[62] This may reflect the different functions of the designs, with the Repertory Theatre being more utilitarian due to the more workaday nature of repertory performance compared to the larger and more monumental temple to music.

[59] Geddes, *Horizons*, pp. 194-98.
[60] Maffei, p. 66.
[61] Schrenk, p. 205.
[62] Schrenk, p. 204.

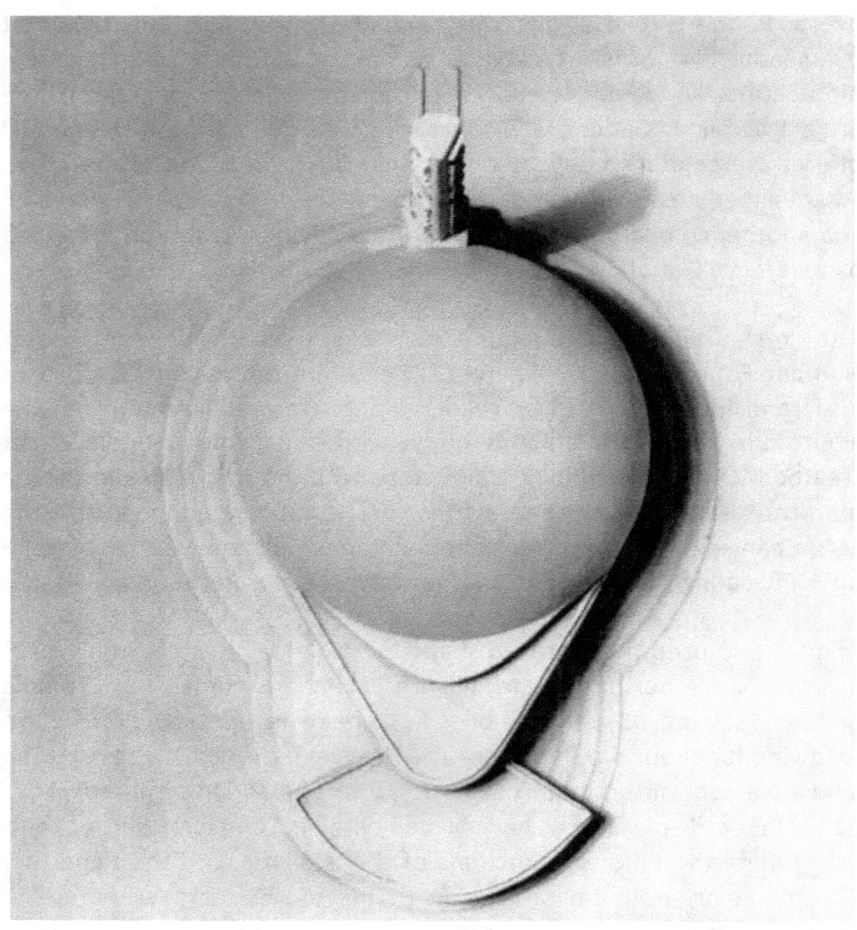

Figure 11. Theater Number Fourteen model. Designed by Norman Bel Geddes, 1922. Photographer: Maurice Goldberg. Source: *Horizons*, p. 160.

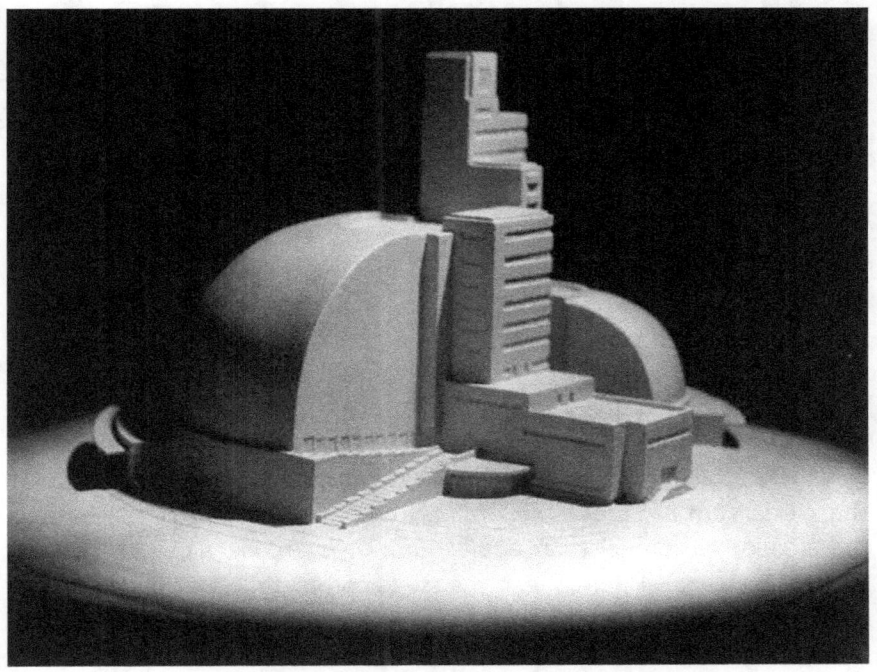

Figure 12. Repertory Theater model. Designed by Norman Bel Geddes, 1929. Photographer unknown. Source: *Horizons*, p. 147.

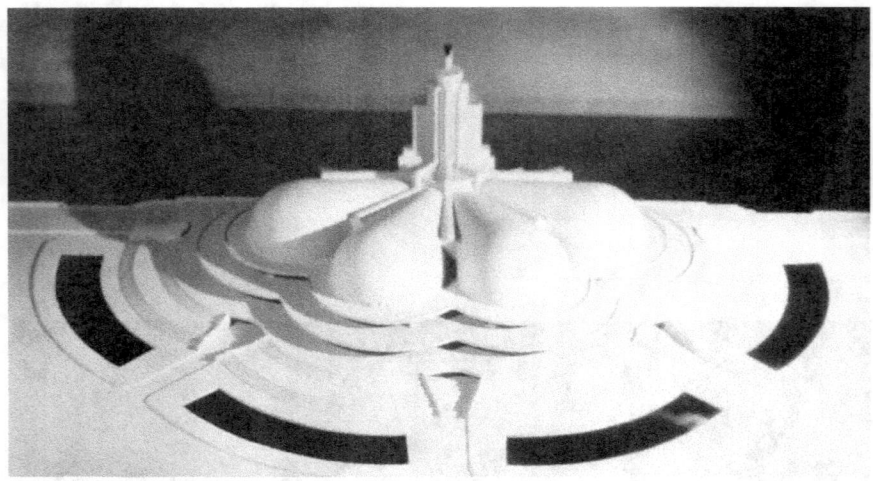

Figure 13. Temple of Music model. Designed by Norman Bel Geddes, 1929. Photographer: Maurice Goldberg. Source: *Horizons*, p. 167.

In a piece on 'Theory of Design' for the fourteenth edition of the *Encyclopaedia Britannica*, Geddes wrote that watching a play through an arch was like asking an audience to watch a boxing match through one and compared watching a play in the round to the experience of viewing a sculpture in an art gallery where one naturally wished to see the piece from all sides.[63] Accordingly, his theatre designs emphasised the circular or semi-circular auditorium, or even, like Theater Number 14 (1922, Figure 14), envisaged the stage completely surrounded by the audience as he tried to break down the barrier between the actors and the audience and return to theatre's original forms.[64]

Theatre Number 6 (c. 1914-22, Figure 15), which had its roots in his 1914 essay titled 'Main Features of a Theatre for a More Plastic Style of Drama', was such an attempt to return to theatre's roots in the Greek theatre-in-the-round with its strong democratic connotations. It would have had only one class of seats and, Geddes claimed, no bad seats in the house. The exterior form of number six was strikingly similar to the

[63] Darwin Reid Payne, *The Scenographic Imagination* (Carbondale: Southern Illinois University Press, 1981), p. 7.

[64] Jeffrey L. Meikle, '"A Few Years Ahead": Defining a Modernism with Popular Appeal', in *Norman Bel Geddes Designs America*, ed. by Donald Albrecht (New York: Abrams, 2012), pp. 114-35 (p. 122).

Repertory Theatre, being principally determined by interior function.[65] Each had dome-shaped auditoria of different sizes accompanied by boxy behind-the-scenes spaces and tall staggered skyscraper-like office space nestled between the domes without any sense of symmetry. All, according to Laura McGuire, possibly influenced by European modernist and Russian Constructivist design of which Geddes was probably aware.[66]

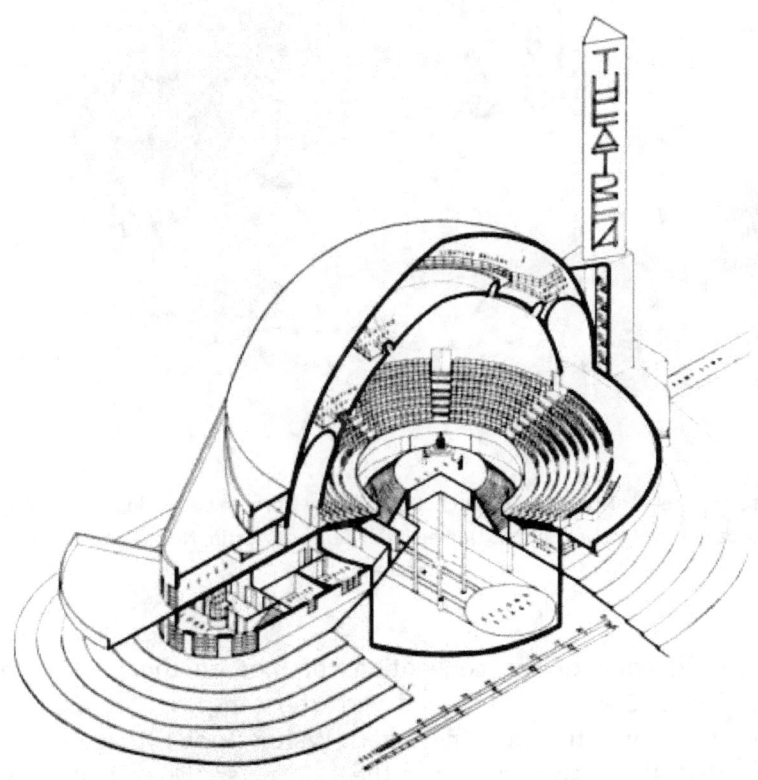

Figure 14. Theater Number Fourteen cut-away drawing. Designed by Norman Bel Geddes, 1922. Source: Hekman Digital Archive.

[65] Laura McGuire, 'Theaters', in *Norman Bel Geddes Designs America*, ed. by Donald Albrecht (New York: Abrams, 2012), pp. 172-83 (pp. 173-74).
[66] McGuire, p. 177.

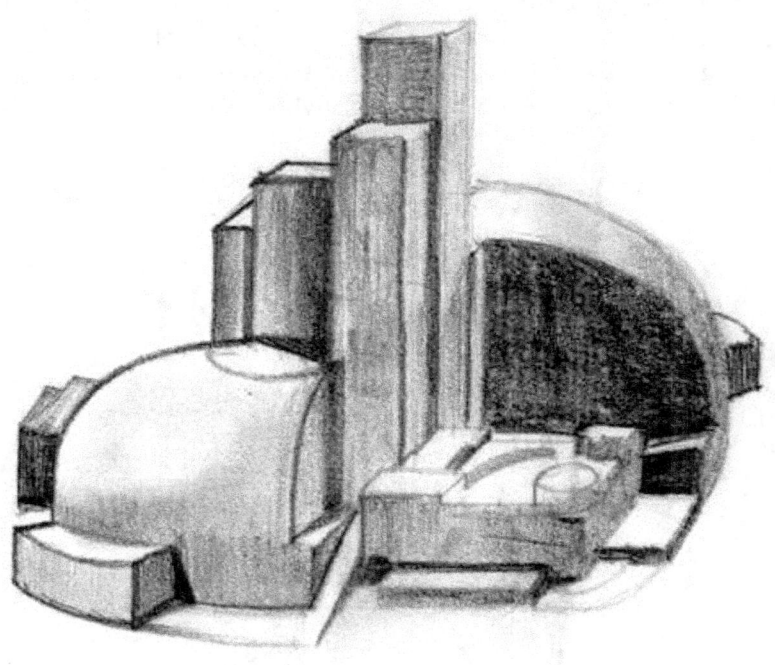

Figure 15. Theater Number Six sketch. Designed by Norman Bel Geddes, c. 1914-22. Source: Harry Ransom Center, University of Texas at Austin, Norman Bel Geddes Database.

Geddes's rejection of the conventions of modern theatre design in favour of the Greek form chimed with the sense in Depression era America that it was time for a new start. Walter Dorwin Teague claimed in 1939 that American designers in the 1930s were like primitives with no theory or vocabulary of ornament behind them, and 'that is why so much of our work today has a certain stark and simple quality that relates it very closely to the primitive work of Greece and the primitive work of Egypt.'[67]

[67] Martin Greif, *Depression Modern: The Thirties Style in America* (New York: Universe Books, 1975), pp. 34-35.

Martin Greif has written in *Depression Modern* (1975), that the reaction of the American designer to the Depression was not to turn to a nostalgic pre-industrial past, but to look for entirely new forms that would grow organically out of current needs with the progressive removal of all ornamentation until, in its purest form, there was not 'a single detail that could be called extraneous' or 'a line that did not seem inevitable.'[68]

According to Greif, even the three speed lines, the Art Deco 'zigzag gone straight', so characteristic of the period, were nothing more than a lazy default ornament for an era that naturally had none.[69] Greif writes that the period was characterised by a movement away from the vertical and the straight line towards the horizontal and the curve which could be employed either for functional, and therefore noble ends, or for debased purposes as marketing tools.[70] There was an inherent tension between these two possibilities and many designs fell into a grey area, combining curving streamlines that naturally reflected the ideal form of an object in generating the minimum of wind-resistance with a strong element of aesthetic choice in streamlining static objects. Even where streamlining served no practical purpose, however, it retained its symbolic function of expressing modernity and the optimism of the American people in the face of adversity.[71]

New materials and methods of manufacturing also allowed innovations in transportation and consumer design. Steel sheet could replace cast iron in domestic appliances, aluminium made products lighter, and stainless steel could provide a shiny silver coat for trains such as the 1934 Burlington *Zephyr* (Figure 16), the first of the streamliners, that transformed the appearance of the locomotive and created a genre of 'Zephyr shrouds'.[72]

[68] Greif, p. 31.
[69] Greif, pp. 31-32.
[70] Greif, p. 23.
[71] Greif, p. 36; Hillier and McIntyre, pp. 105-07.
[72] Innes, *Designing Modern America*, p. 115.

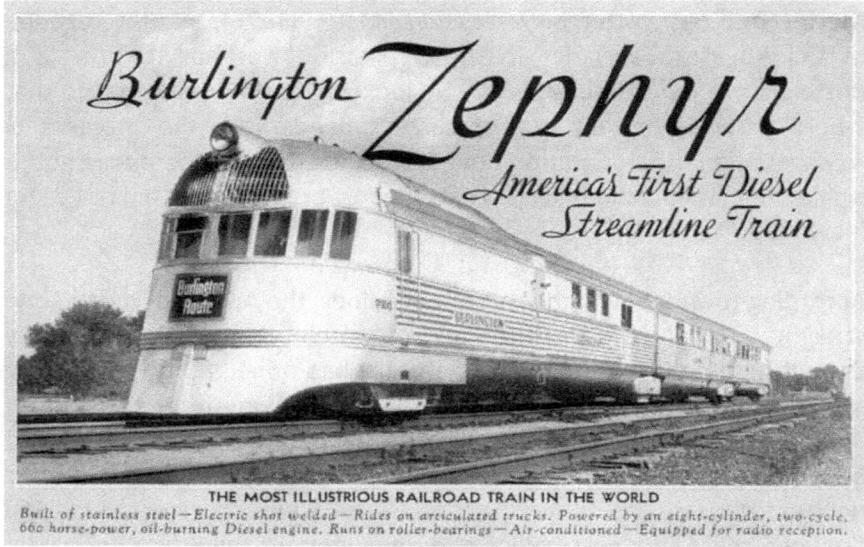

Figure 16. Burlington Zephyr America's First Diesel Streamline Train, c. 1934. Photographer unknown. Source: Wikimedia Commons.

Glass was highly malleable when hot and plastics could be poured and moulded in a way that made curved forms easy to create and removed the technical difficulties and manufacturing costs of trying to create perfect rectangles to high tolerances.[73] Geddes took full advantage of the new materials particularly in his designs for smaller objects such as radios and domestic appliances as in his rounded vacuum cleaner design for Electrolux of 1934/35 (Figure 17). The design seems to have a clear front and rear and a natural direction of travel with three louvered lines along half the length that give the impression of windows, making the whole resemble a modernist railway engine.[74]

[73] Hanks & Hoy, p. 27.
[74] Maffei, pp. 121-22.

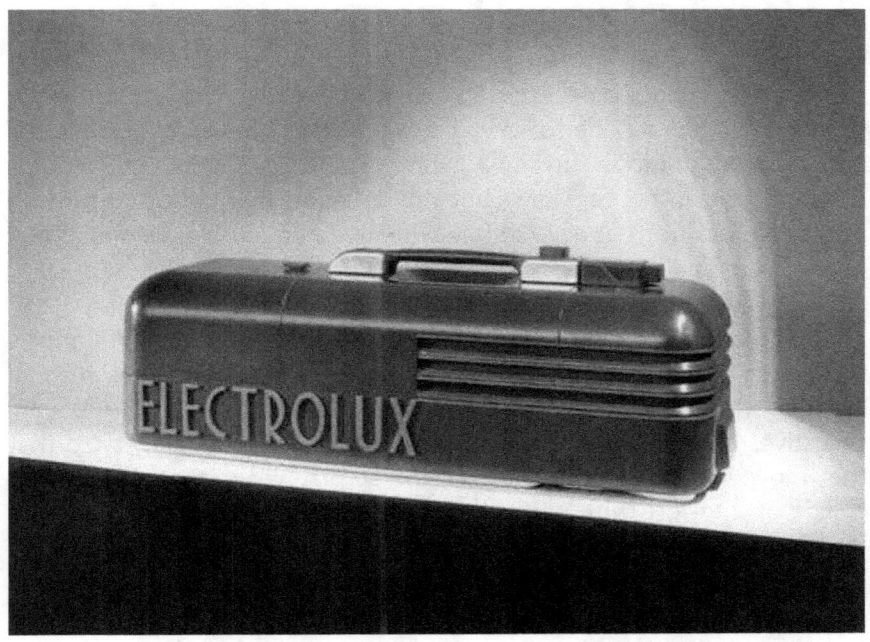

Figure 17. Electrolux vacuum cleaner. Designed by Norman Bel Geddes, c. 1934-35. Photographer Richard Garrison. Source: Harry Ransom Center, University of Texas at Austin, Norman Bel Geddes Database.

8 Shell Oil City of Tomorrow

In 1936, Geddes was commissioned by J. Walter Thompson to design an advertising campaign for Shell Oil in 1937 to promote their new Super-Shell Gasoline. Although he was only asked to look at ideas for traffic planning, he quickly expanded the initial brief into a much larger and more ambitious project relating to the future of cities and transportation generally by gathering statistics that he projected into the future to identify a crisis point at which the whole transport system would become completely clogged with traffic. The self-identified future crisis licenced the larger project that Geddes developed and played on contemporary worries about congestion and its retarding effect on progress.[75]

[75] Sandy Isenstadt, 'The Future is Here: Norman Bel Geddes and the Theater of Time', in

Naturally, Geddes also designed a solution to the problem he had identified, a system of segregated traffic and urban planning that was created in a model dated to 1960 and named the City of Tomorrow (Figure 18). The model also served as a prototype for parts of Geddes's much more ambitious Futurama exhibit at the 1939 New York World's Fair.[76] It was only 6 feet long but much larger in ambition and when photographed from above complete with simulated clouds and urban haze, created a convincing impression of a future metropolis.

The simulation of reality through the aerial photography of models recurred throughout Geddes's work and drew on techniques he had learned while designing stage sets from an aerial view, one of the objectives of which was to organise 'all phases of stage activity so that they move in a series of traffic patterns, so planned so that they cannot collide or interfere with each other'.[77] The aerial perspective had been increasingly important since aerial photography was used in the First World War and Le Corbusier had written enthusiastically about it in *Aircraft* in 1935. In that book he had extolled the benefits of the 'bird's eye view' and of the aircraft as the 'advance guard of the conquering armies of the New Age' that revealed the bankruptcy of the city as it existed at that time.[78]

Geddes proposed the segregation of long distance and local traffic and the use of different levels with deliveries to commercial buildings taking place underground, regular vehicle traffic at ground level, and pedestrians on elevated walkways on the first storey where the building entrances and shop fronts would also be located. He believed that this would allow traffic to move at continuous speed without the stop-start motion that applied in congested areas where the flow was broken by stop lights, junctions, and pedestrians. Bypasses would allow long-distance traffic to avoid urban centres completely while overpasses would allow vehicles to change direction without stopping, so streamlining the movement of traffic and increasing efficiency. These

Norman Bel Geddes Designs America, ed. by Donald Albrecht (New York: Abrams, 2012), pp. 136-53 (pp. 142-44).
[76] Marchand, p. 107; Isenstadt, pp. 142-45.
[77] Meikle, *Twentieth Century Limited*, pp. 207-08.
[78] Le Corbusier, *Aircraft*, (London: The Studio, 1935), p. 6.

changes would be combined with a degree of vehicle automation that presaged the idea of the driverless car.[79]

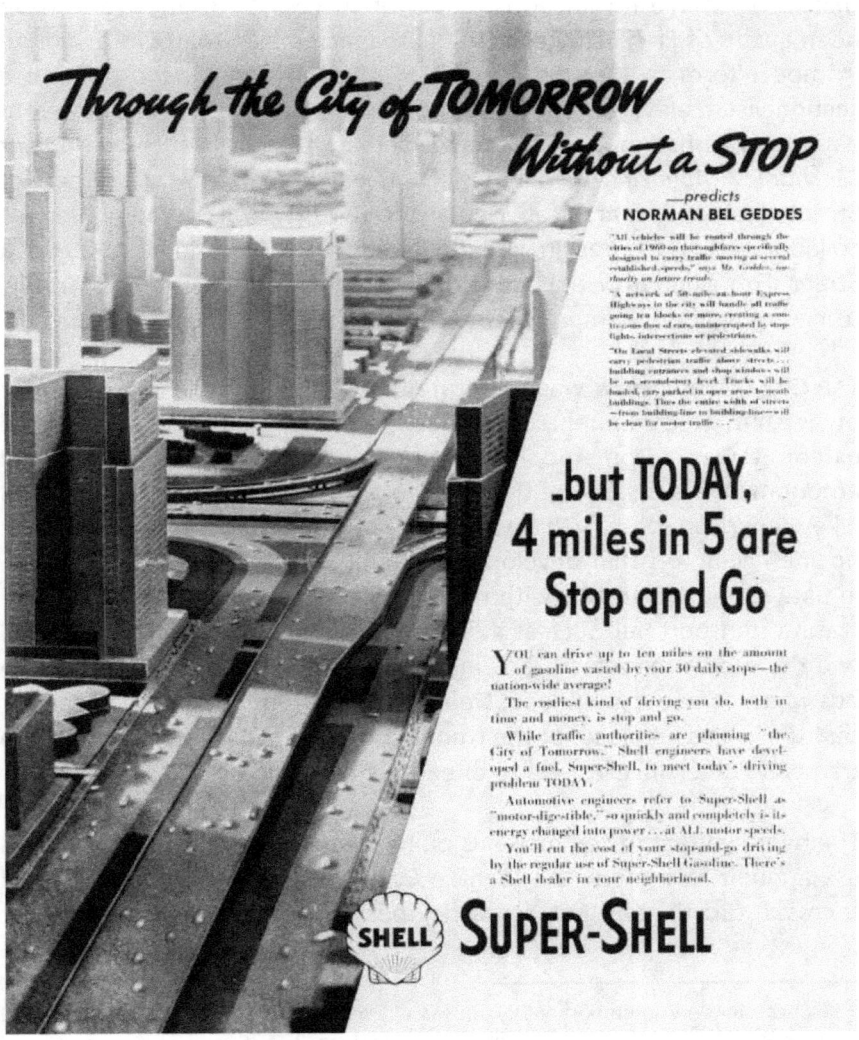

Figure 18. Shell advertisement featuring the City of Tomorrow, 1937. Photographer unknown. Source: Wikimedia Commons.

[79] Isenstadt, pp. 142-45.

Such ideas were not new. Geddes owned a copy of Le Corbusier's *The "City of Tomorrow" and Its Planning* (Payson and Clarke, New York, 1929) which advocated many of the same ideas within an overall theme that 'a city made for speed is made for success'.[80] He must also have been aware of Frank Lloyd Wright's Broadacres plan that was exhibited in model form in New York in 1935.[81] *Scientific American* showed a sectionalised 'elevated sidewalk' in 1913 and such ideas transitioned to early science fiction magazines and factual periodicals such as *Popular Mechanics Magazine*.[82] Miller McClintock, director of the Bureau of Street Traffic Research at Harvard University with whom Geddes collaborated on the design, had discussed similar ideas in his 1925 book *Street Traffic Control* and developed a theory of 'frictionless traffic' using segregation to improve efficiency and reduce accidents.[83]

The City of Tomorrow was predicated on the ubiquity of individual car ownership which benefited Geddes's client Shell but which, to the extent it was automated, also went against the sense of personal autonomy that was one of the automobile's principal selling points and a key American value.[84] This was to be a city on a strict grid system, with no inefficient organic development determined by individual human initiative, and apparently with nothing old and little green space. There was no transport hub such as a railway station, possibly because to Shell and the motor manufacturers, all public transportation apart from the bus was a competitor. Indeed, General Motors agreed with Le Corbusier that there was no place for the tram in the city and attempted to buy up tramways and convert them to bus companies.[85]

The overall effect of the model is quite regular due to the block system used, albeit less geometric than Le Corbusier's *City of Tomorrow*, and seems futuristic but not fantastic, possibly reflecting the fact that

[80] Le Corbusier, 'A Contemporary City', in *The City Reader*, ed. by Richard T. LeGates and Frederic Stout, 4th edn (New York: Routledge, 2007), pp. 322-30.

[81] Isenstadt, p. 145.

[82] Norman Brosterman, *Out of Time: Designs for the Twentieth-Century Future* (New York: Abrams, 2000), pp. 32-33 & 40.

[83] Miller McClintock, *Street Traffic Control* (New York: McGraw-Hill, 1925), pp. 80-81; Maffei, p. 150.

[84] Maffei, p. 152; Szerlip, p. 217.

[85] Le Corbusier, 'A Contemporary City', p. 340; Meikle, *Twentieth Century Limited*, p. 207.

Geddes was only looking forward 23 years, not a century as forecasters often did, and also because there was a general feeling, shared by Geddes, that the future was arriving much faster than it had done in the past.[86]

The sense that the future was not far away, reflected his personal philosophy but it was also a pragmatic response to the needs of his customers for whom there was no money to be made in something that could only exist in a century's time. Nor was there very much merit for Geddes in proposing such concepts in case he came to be seen as detached from reality. His City of Tomorrow and Futurama exhibits each only looked forward to 1960 and his written output, which was generally in popular publications, stressed the near term nature of his ideas in titles such as 'Ten Years From Now' (*Ladies Home Journal*, January 1931), the 'House of Tomorrow' (*Ladies Home Journal*, April 1931), and 'Dreamlining Tomorrow' (*Mademoiselle*, March 1944).

For Geddes, the future was less fantasy and more like an iteration of current trends produced by continuous evolutionary product development in a cycle of market research, design, retooling, and production.[87] This was similar to the philosophy that Christine Frederick had advocated in *Selling Mrs. Consumer* that kept consumers and producers happy and contributed to overall prosperity, but which also involved high levels of redundancy in existing forms and machinery and was seen by some as wasteful. In 1934, George Nelson described Geddes in *Fortune* magazine as a 'bomb-thrower' who had 'cost American industry a billion dollars', and implied that showmanship had got the upper hand in his work by describing him as the 'P.T. Barnum of industrial design'.[88]

Geddes was a master of combining other people's ideas with his own into a near-term vision that was just within the grasp of the contemporary imagination but without going so far as to be incredible.[89] By extrapolating existing trends and technological advances he was able

[86] Isenstadt, p. 150.
[87] Isenstadt, p. 139.
[88] Szerlip, p. 156.
[89] Isenstadt, p. 141.

to imbue his ideas with an aura of inevitability as though society was moving incrementally towards a point of singularity in efficiency.

Because the approach was incremental, this was also a future achieved without any of the radical discontinuities more typical of societal change such as political upheaval or warfare. Le Corbusier's argument in *Aircraft* that the aerial view was an 'indictment' of current cities and the capitalist system that had created them, revealing misery that could only be rectified by wholesale destruction and rebuilding, would never have done for Geddes or his clients.[90] Theirs was an optimistic American modernism predicated on the continuation of a flourishing capitalist economy and one that did not consider the unintended consequence or the possibility that their utopian visions might turn dystopian.[91]

The power of men like Geddes to create such an environment was not in question. Images of him playing with tiny skyscrapers, of Le Corbusier's giant hand hovering above the Ville Contemporaine, and of groups of planners stood around models, are all common in the literature, the contrasts in scale reinforcing the idea of the visionary planner gazing down from on high.[92] Geddes wrote to his wife in 1938 that he 'walked around with pockets and hands full of skyscrapers' while she wrote back, amused at his 'playing God [...] plunking down skyscrapers where you want'.[93] In fact, the light-hearted remarks possibly reflected the reality of Geddes's and other modernist planners sense of themselves as occupying a place that Adnan Morshed has described as a sort of synthesis between a Nietzschean *Übermensch*, a totemic modernist aviator with God-like abilities, and the architect from Ayn Rand's *The Fountainhead* (1943).[94]

As Le Corbusier had written, the aerial view provided a sense of perspective impossible from the ground. The greater the altitude, the smaller the city and the more powerful the spectator, and, as has been written, the ability to see everything at once is to acquire a power previously only available to God. Having such power naturally provided

[90] Le Corbusier, *Aircraft*, pp. 11-12.
[91] Isenstadt, p. 151; Szerlip, p. 216.
[92] Adnan Morshed, 'The Aesthetics of Ascension in Norman Bel Geddes's Futurama', *Journal of the Society of Architectural Historians*, 63 (2004), 74-99 (pp. 89, 91, 93-94).
[93] Meikle, *Twentieth Century Limited*, p. 208.
[94] Morshed, pp. 77, 82, 92.

a detachment that made proposals for the demolition of current cities a lot easier to countenance.

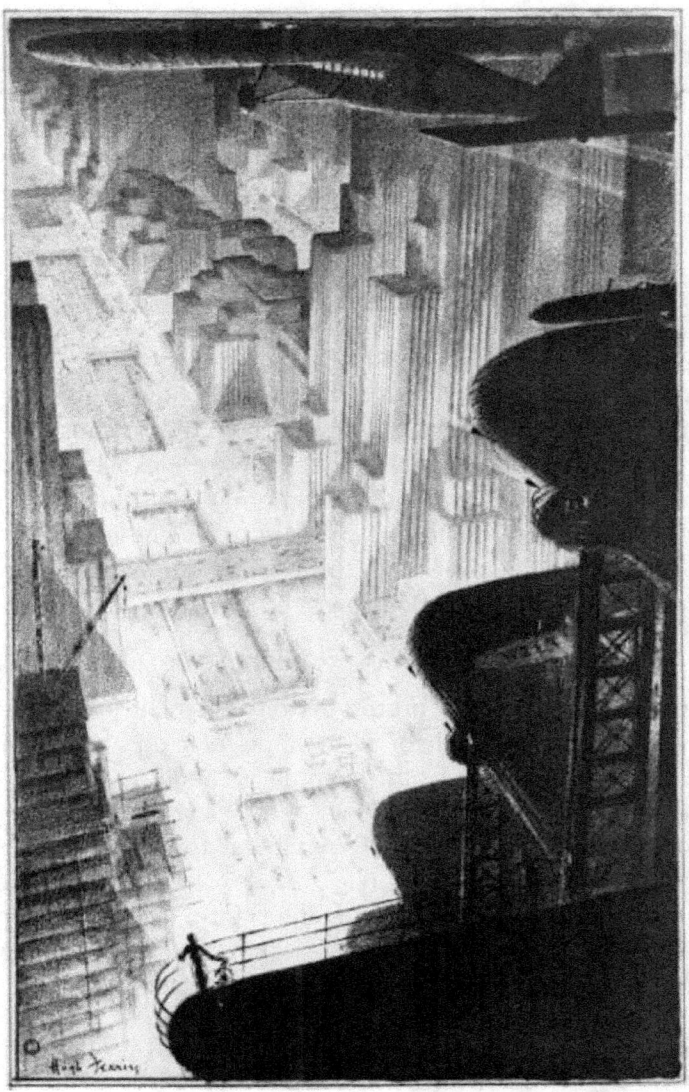

Figure 19. *Skyscraper Hangar in a Metropolis,* Hugh Ferriss, 1930.

By the inter-war years, the aircraft, with its highly streamlined form, had become symbolic of modernity with the consequence that the aviator had become a quintessentially modern figure.[95] One perhaps analogous to the visionary urban planner. Aviation and the aviator became a recurring theme in American popular culture and in art such as Italian Futurism and Hugh Ferriss's *Skyscraper Hangar in a Metropolis* (c. 1925, Figure 19) where a solitary figure stands on a high balcony overlooking a metropolitan city of the future as an aircraft departs above. In H.G. Wells's novel *The Shape of Things to Come* (1933) and the film version *Things to Come* (1936) it is the airmen who reconstruct a ruined earth.

9 Futurama

The 1939 New York World's Fair had been lobbied for since 1934 as a tonic for the Great Depression with a theme of 'Building the World of Tomorrow' and a slogan of 'Dawn of a New Day'. The usual classical motifs of a World's Fair were replaced by an explicitly modernist aesthetic and the normal emphasis on international trade was reduced in favour of a utopian vision of how Americans might live in the future, the products they would be able to buy, and the cars in which they would travel. Over 44 million people visited.[96]

Geddes had anticipated from the start that the Shell Oil City of Tomorrow might serve as a prototype for an exhibit at the New York fair. It was offered to Shell for re-use but rejected and taken up by Goodyear who then pulled out. Eventually, Geddes was able to sell General Motors (GM) an idea that was a huge extrapolation of the City of Tomorrow that he named Futurama. It was to be housed within the Highways and Horizons building (Figs. 20 & 21) that Geddes designed with Albert Kahn as architect and input from Eero Saarinen.[97] His competitors Walter Dorwin Teague and Raymond Loewy were represented in the Ford and Chrysler buildings respectively.

[95] Morshed, pp. 78, 82, 93-94.
[96] Lawrence W. Speck, 'Futurama', in *Norman Bel Geddes Designs America*, ed. by Donald Albrecht (New York: Abrams, 2012), pp. 288-303 (p. 290); Szerlip, p. 216.
[97] Maffei, p. 159.

The Highways and Horizons building served a dual purpose of housing the Futurama exhibit and showcasing GM products but neither function was discernible from the facade which was completely plain apart from its signage (Figure 22) and gave no clue to the shape of the Futurama ride or the real size streets around which the structure was centred. The colour, supposedly metallic grey to match the aluminium skin of the streamlined Douglas DC-3 or the Duco lacquer applied to automobiles, was the colour of the decade; used in the Burlington Zephyr, in Geddes's teardrop cars, on the binding of *Horizons*, and synonymous with the stripped-back aesthetic of streamlining.[98] Visitors queued on two snaking ramps at the front that fitted inside the curve of the hook-shaped façade, and entered the future through a portentous gap that was flanked by the letters G and M.

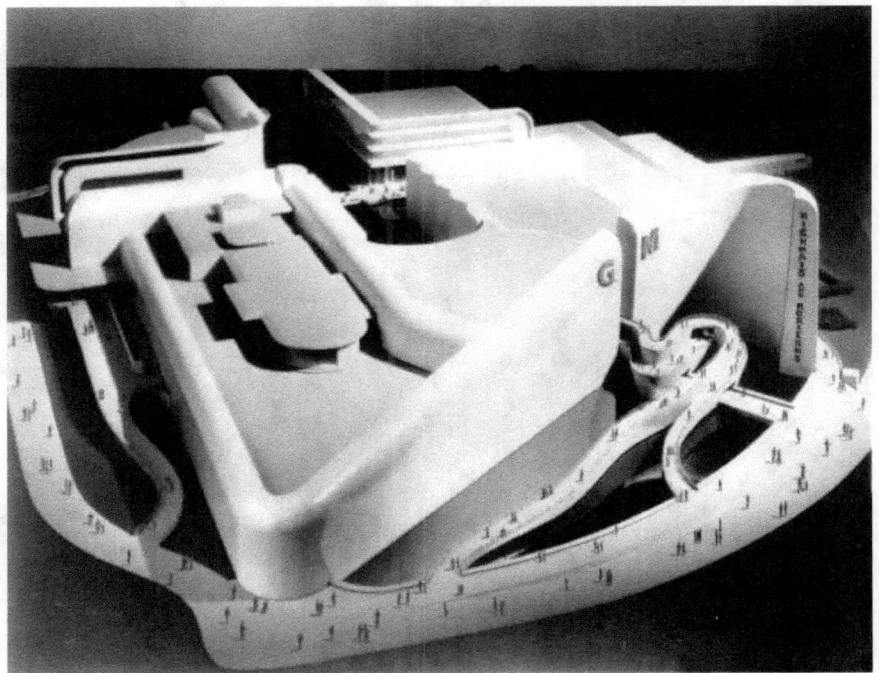

Figure 20. Highways and Horizons building model, c. 1938. Photographer unknown.
Source: New York Public Library.

[98] Jeffrey L. Meikle, "A Few Years Ahead", p. 123; Szerlip, p. 240.

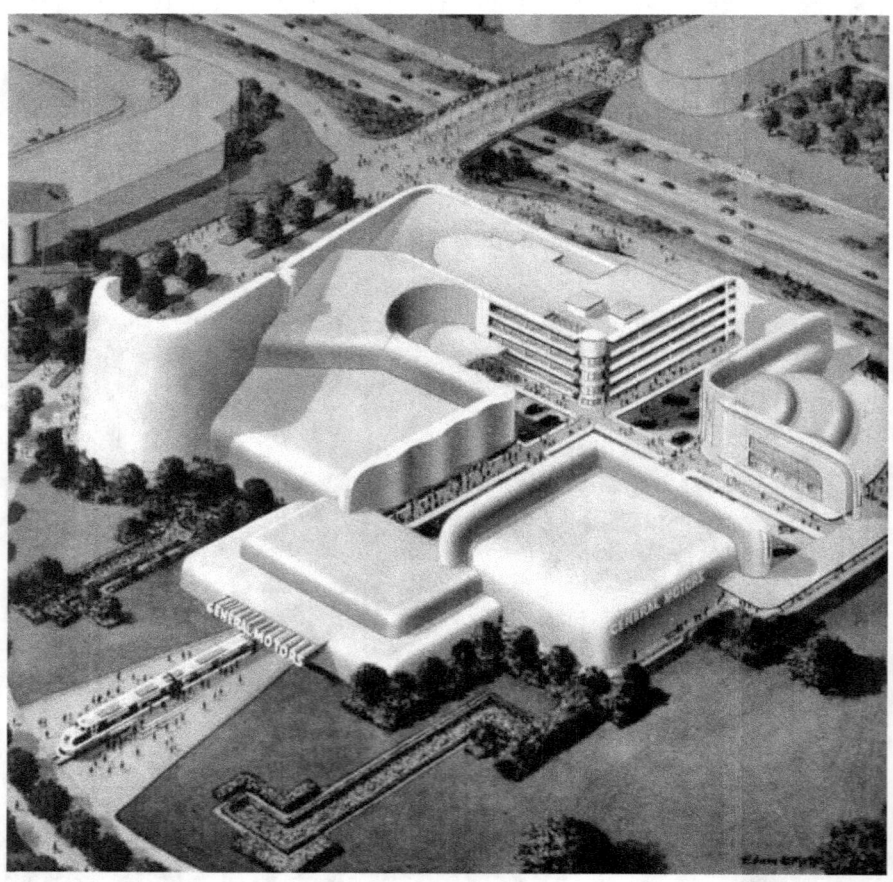

Figure 21. Highways and Horizons building illustration by Edwin D. Mott, c. 1939. General Motors publicity brochure. Source: Wikimedia Commons.

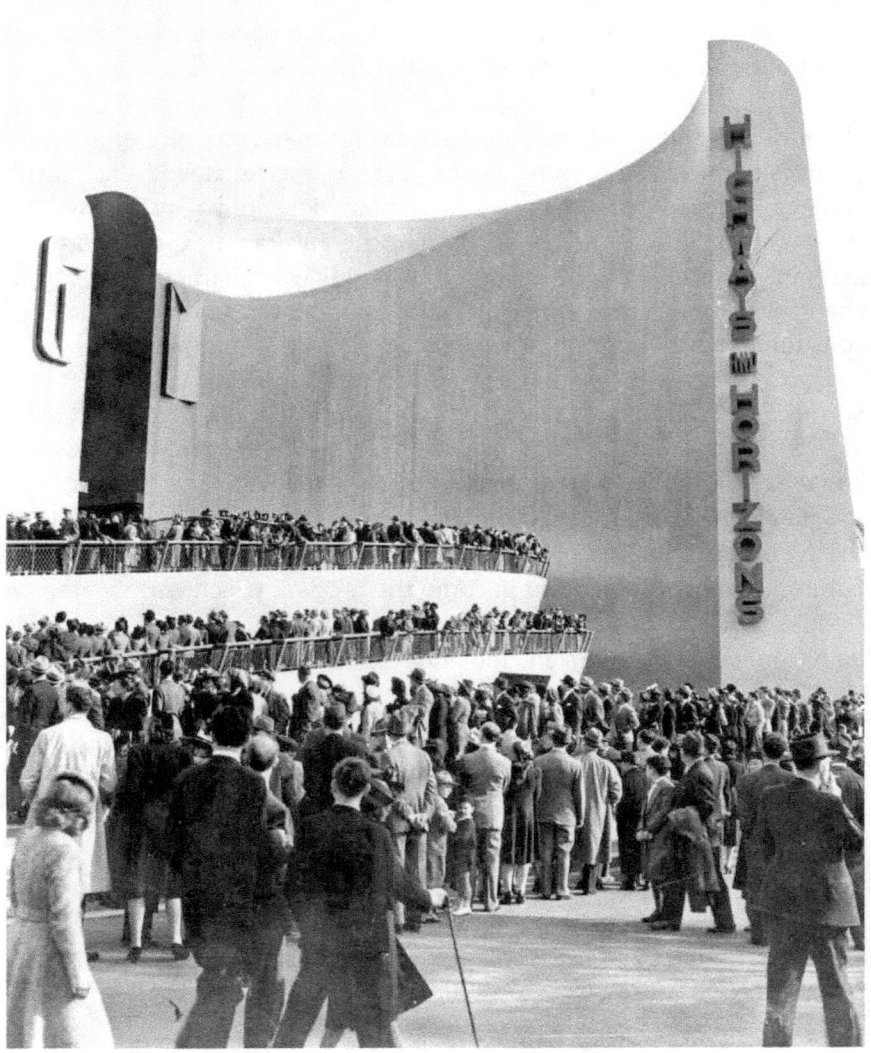

Figure 22. Highways and Horizons building front. Photographer unknown. Source: New York Public Library.

In an act of inspiration that represented the highpoint of his career, Geddes conceived of a giant model landscape of 4/5ths of an acre around which visitors moved on a conveyor belt of a third of a mile while seated in theatre-type chairs whose wide wings concentrated their attention narrowly on the part of the diorama in front of them. The visitor was thus turned into an aviator and experienced the world with the equivalent of an 'airplane eye' (Figs. 23 & 24).[99]

The ride reversed the normal theatrical experience of periodic set changes to move the narrative along. Instead, the set stayed still but the audience moved to the background of a descriptive narration. The reversal of roles and the comparison of the Futurama experience to an assembly line along which a product moves was characteristic of the changing emphasis at the fair and generally from production to consumption and was not missed by contemporary commentators.

Science journalist, David Dietz, wrote of Futurama in 1939 that 'It is, in effect, a continuous assembly line with the exception that nothing happens to the unit moving along the line - the spectator - other than the information poured into him via his eyes and ears.'[100] Rather than the emphasis being narrowly on the products sold by GM, arguably in Futurama the consumer had become the product which was created by Geddes in order to keep up with the flood of mass produced goods being made by American industry as anticipated by Arens and Sheldon.[101]

[99] Morshed, p. 77.
[100] Maffei, p. 171.
[101] Maffei, p. 171.

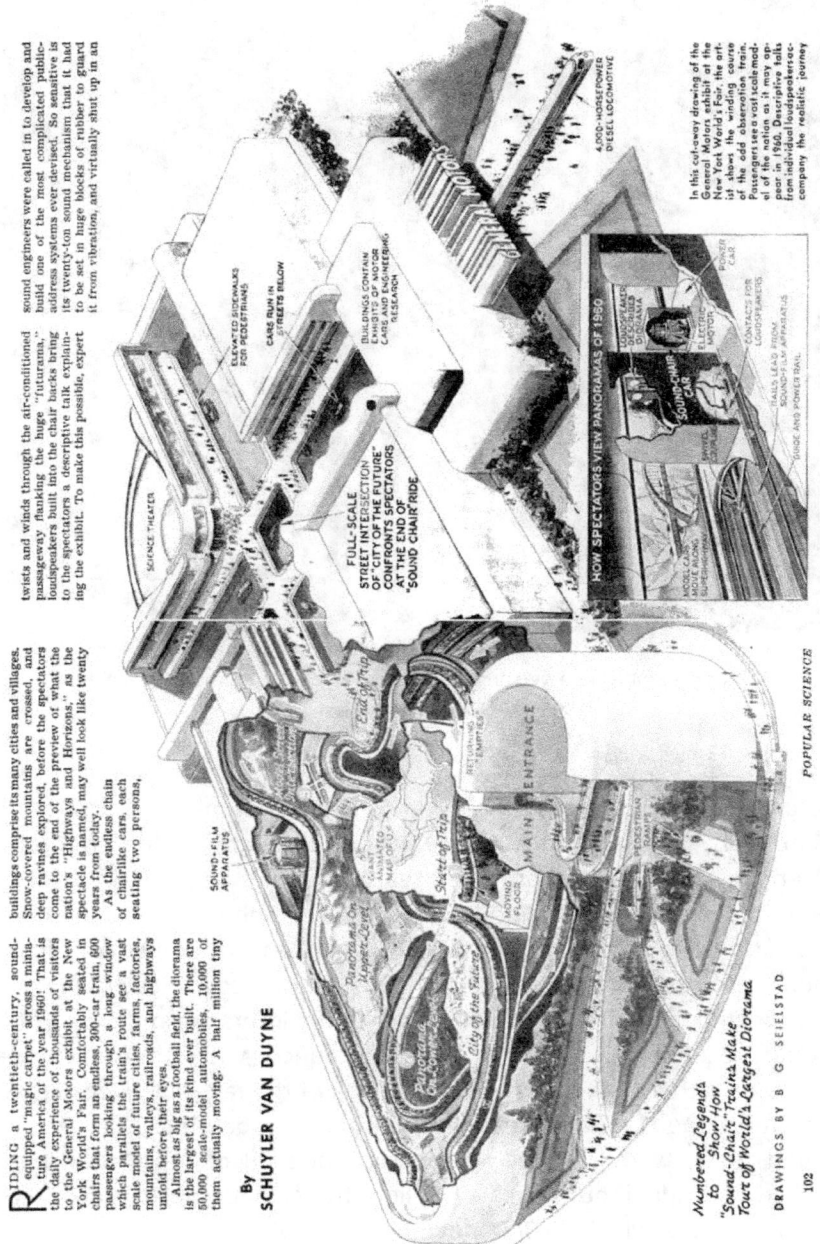

Figure 23. Highways and Horizons cut-away illustration by B. G. Seielstad. *Popular Science*, c. 1939.

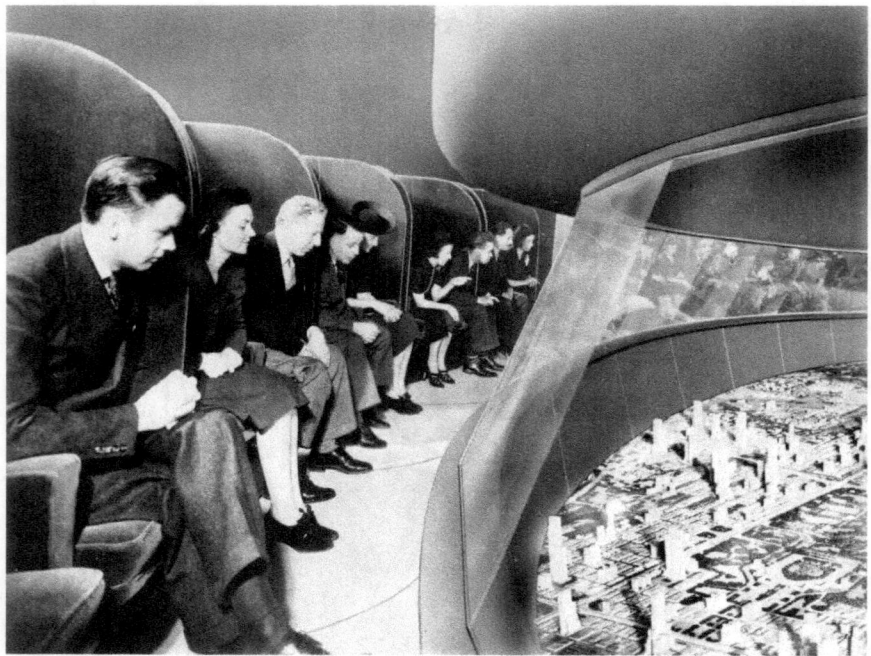

Figure 24. Futurama ride and diorama, c. 1939. Photographer unknown. Source: New York Public Library.

Before viewing Futurama, however, visitors first passed through the Map Lobby, a space made to seem huge through lighting effects and diverging walls whose principal feature was a large (60 x 100 ft) animated map of the United States that seemed to hang in the air against a twilight sky.[102] It showed the American road network as it was, then a projection of the congestion that would occur if car usage grew as expected, and finally a projected system of interstate motorways that would resolve the problem. In accordance with the heightened domestic rather than international agenda of the fair, however, this was a plan for the United States only. Visitors then boarded the 'carry-go-round' to view the model which was made up of more than half a million individual buildings, a million trees, and more than 50,000 automobiles of which 10,000 moved (Figure 25).[103]

[102] Marchand, p. 111.
[103] Morshed, p. 74.

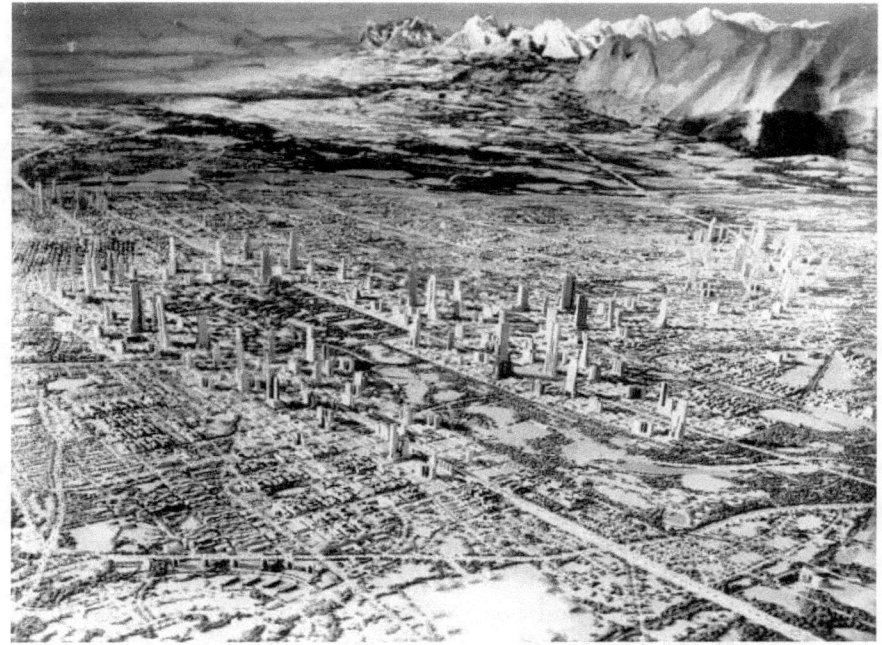

Figure 25. Aerial view of the Futurama model, c. 1939. Photographer unknown. Source: New York Public Library.

It was a vision of America in 1960 in which freedom to move through transportation and infrastructure improvements, principally a national system of motorways, was made synonymous with personal freedom and prosperity, or, as General Motor's chairman, Alfred P. Sloan, wrote in the visitor's brochure, 'history shows that the progress of civilization has run parallel to advancement in transportation'.[104]

As usual with Geddes, this was something that 'could be built today'.[105] The exhibit was seen by President F.D.R. Roosevelt and the inter-state highway system that was created by the acts of Presidents Roosevelt and then Eisenhower after the Second World War bore a strong resemblance to that envisaged in Futurama and in Geddes's *Magic Motorways*.[106] Of course, Geddes was not the only factor in this, the

[104] General Motors, *Futurama*, ([Detroit?]: General Motors, 1939), p. 1.
[105] Norman Bel Geddes, *Magic Motorways* (New York: Random House, 1940), p. 10.
[106] Speck, pp. 298 & 302.

lobbying of commercial interests was also important as the utopia that Geddes envisaged was also a utopia for General Motors and Shell Oil as DiMento and Ellis have observed.[107]

Efforts were made to ensure that the diorama remained credible, with the inclusion of 'junk', and areas of construction to reinforce the point that this was a near-term vision. Parts were created to a level of detail that allowed them to be photographed close-up for publicity purposes although visitors would only see them from a distance. The whole struck a careful balance between theatrical effect and the need not to stretch the viewer's credibility too far, or, as Geddes put it, the need to create 'a future that retains enough of 1939 to keep it from being fantastic'.[108] After all, as Geddes said, 'I'm no Jules Verne'.[109]

After a series of theatrical light and scale changes at the end of the 15 minute ride, the visitor emerged on an elevated pedestrian walkway above a full scale traffic intersection (Figure 26) as though they had time-travelled to 1960 and became part of the model they had just seen. Geddes had wanted teardrop-shaped cars similar to those used in the model to be visible and drivable on the roadway below but GM insisted instead that its current vehicles be used which contrasted somewhat with the modernist atmosphere of the architecture and threatened to spoil the conceit that the visitor was in the future.[110]

In the buildings around the intersection, GM people were on hand to promote the company's latest vehicles and the products of GM-owned companies such as Frigidaire.[111] According to surveys, the Futurama experience was the most popular exhibit at the fair.[112] As they exited the ride, visitors were given a badge that read 'I Have Seen the Future'.

[107] Joseph F. C. DiMento and Cliff Ellis, *Changing Lanes: Visions and Histories of Urban Freeways* (Cambridge, MA: MIT Press, 2013), p. 53.
[108] Maffei, pp. 157-58.
[109] Szerlip, p. 156.
[110] Szerlip, p. 240.
[111] Speck, pp. 294-96.
[112] Marchand, pp. 104-05.

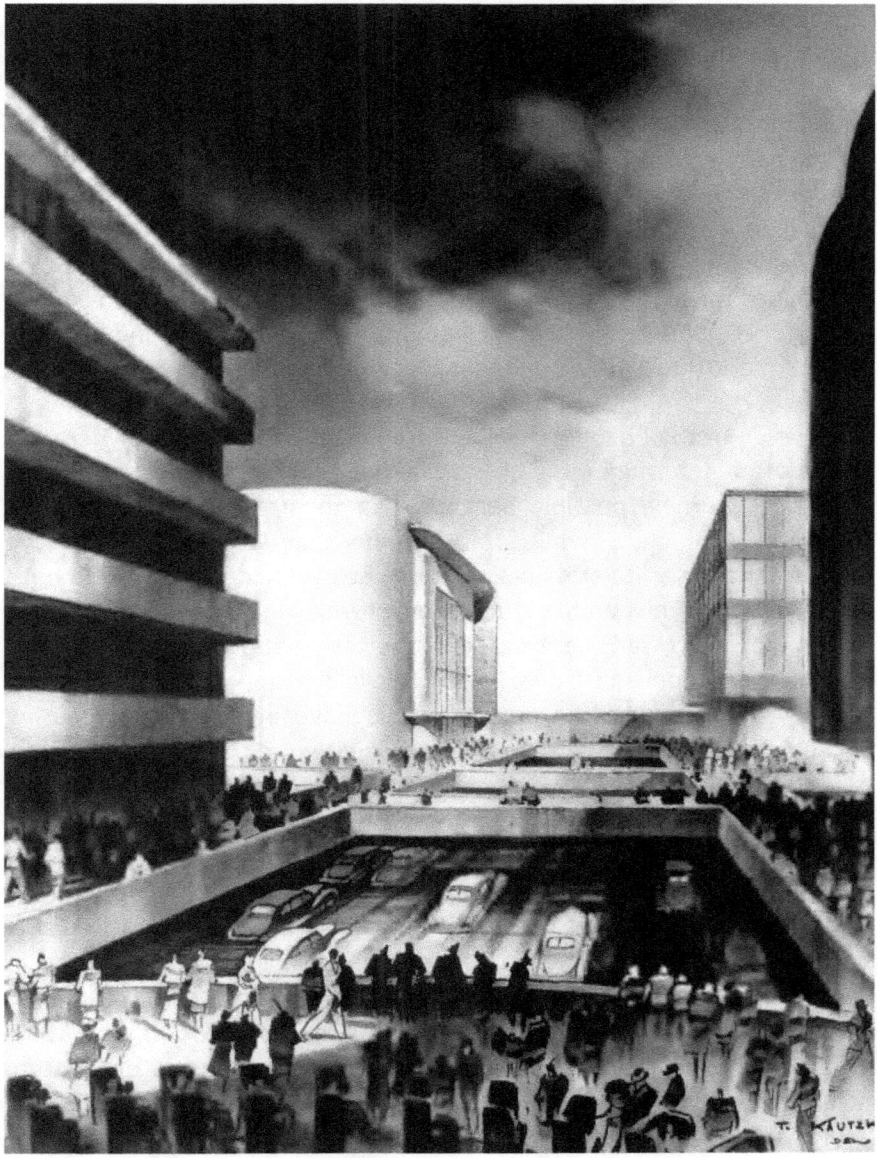

Figure 26. Futurama intersection. Page from General Motors Highways and Horizons brochure, 1939. Artist: Ted Kautzky.

The fact that the Highways and Horizons building was effectively inward looking with its front on the inside, reinforced the feeling that the visitor had on exiting the ride of time-travelling and raises questions about the status of Futurama. It inspired pale imitations in theme-parks but was much more than some sort of fairground ride to those that experienced it. The narrow focus of the individual ride provokes comparison with the modern idea of the virtual reality experience and even hard-bitten journalists reported a transcendental experience.[113] The role of the visitor is ambiguous, part theatre-goer, part commodity being packaged by Geddes for consumption by GM, and possibly a participant in a piece of performance art. Does Futurama's commercial function and lack of a fully thought-through vision prevent it being considered a work of art?

The design of the building was contrary to Geddes's theatres where the inside often determined the outside, although both took the visitor on a theatrical journey, possibly because in a theatre the audience were spectating the show while at Futurama they became part of the performance in a life size version of the story. Inside and outside both exhibited modernist architectural themes with long curving streamlined forms, flat roofs, sans-serif modernist lettering and the stripping away of ornamentation and excess detail, while the aerial view (Figure 21) looks very much like the building could have been assembled using pieces moulded from plastic like a Bakelite radio. The front had a sculptural monumentality, the austerity of which was marred only by the queues outside.

The public reaction to Futurama was highly positive. There was no suggestion that anyone's home might cease to exist to build the future on show within or that one of its functions was to sway public opinion in favour of public works funded by taxation. Media and critical responses were more mixed. Lewis Mumford, writing in *The New Yorker* in 1939, praised the cleverness of the exhibit and its showmanship but hinted, without mentioning politics, at the somewhat regimented nature of the world of 1960 and the degree of control over individual movement that would be required to achieve the streamlined and co-ordinated transport system of the future.[114]

[113] Maffei, p. 161.

[114] Lewis Mumford, 'The Sky Line in Flushing: West is East', in *Sidewalk Critic: Lewis Mumford's Writings on New York*, ed. by Robert Wojtowicz (New York: Princeton

E.B. White, also for *The New Yorker* knew he was being drugged, saying 'When night falls in the General Motors exhibit and you lean back in the cushioned chair [...] and hear [...] the soft electric assurance of a better life - the life which rests on wheels alone - there is a strong, sweet poison which infects the blood. I didn't want to wake up.'[115] The authoritarian overtones were obvious to him, 'there is no talking back in Tomorrow'.[116] Stuart Chase, a long-standing critic of excessive production and waste, asked in a 1940 article for *Cosmopolitan*, knowingly titled 'Pattern for a Brave New World', whether we would enjoy living in this sort of world? Was it 'too clean, too fast, too neatly planned?'[117]

10 Conclusion

Between 1932 and 1939, Norman Bel Geddes moved from completing relatively small design jobs that he combined with propagandising streamlining and drawing up large near-fantasy projects, to designing whole future environments in accordance with his self-image as a futurist and visionary. Streamlining was still there, in the smoothness and efficiency with which everything would work in the future but the overall theme had changed from aerodynamics to human progress in general.

The size of the vision proposed in Futurama, however, suggested a degree of central control and organisation, symbolised by the model's transport system, which had authoritarian overtones that were not much appreciated at the time despite the rise of fascism in Europe and which ran contrary to the American values of private enterprise and individual freedom.

The creation of the ideal society also, like creating the ideal streamlined motor car, required the removal of any element that prevented the smooth functioning of the whole. It is hard to see much room for

Architectural Press, 1998), pp. 235-41.
[115] Maffei, p. 161.
[116] Maffei, p. 165.
[117] Maffei, p. 163; Margolin, p. 366.

dissent in the world of Futurama in which, presumably, Geddes's 'parasite drag' and Adolf Loos's 'stragglers' have both been eliminated along with any awkward organic or unplanned development. There was thus a parallel between the streamlined and centrally planned world of the future and the breeding out of unwanted characteristics advocated by the Eugenicists. This would also have been a static world, since utopia cannot be improved upon, in the same way as the progressive removal of ornament and extraneous detail in design left only the essential form. Central to its creation would be the judgement of the planners and self-appointed visionaries such as Norman Bel Geddes.

Bibliography

Primary sources

Calkins, Earnest Elmo, 'Beauty the New Business Tool', *Atlantic Monthly*, August 1927, 145-156 <https://www.theatlantic.com/magazine/archive/1927/08/beauty-the-new-business-tool/376227> [accessed 19 February 2018]

Frankl, Paul T., *New Dimensions: The Decorative Arts of Today in Words & Pictures* (New York: Payson & Clarke, 1928)

Frederick, Christine, *Selling Mrs. Consumer* (New York: Business Bourse, 1929)

Geddes, Norman Bel, *Horizons* (Boston: Little, Brown, 1932)

Geddes, Norman Bel, *Magic Motorways* (New York: Random House, 1940)

Geddes, Norman Bel, *Miracle in the Evening: An Autobiography*, ed. by William Kelley (Garden City, NY: Doubleday, 1960)

Geddes, Norman Bel, 'Streamlining', in *The Industrial Design Reader*, ed. by Carma Gorman (New York: Allworth Press, 2003), pp. 135-39

General Motors, *Futurama*, ([Detroit?]: General Motors, 1939)

Le Corbusier, 'A Contemporary City', in *The City Reader*, ed. by Richard T. LeGates and Frederic Stout, 4th edn (New York: Routledge, 2007), pp. 322-30

Le Corbusier, *Aircraft*, (London: The Studio, 1935)

Loos, Adolf, 'Ornament and crime', in *Programs and Manifestoes on 20th-Century Architecture*, ed. by Ulrich Conrads, trans. by Michael Bullock (Cambridge, MA: MIT Press, 1970), pp. 19-24

McClintock, Miller, *Street Traffic Control* (New York: McGraw-Hill, 1925)

Mumford, Lewis, 'The Sky Line in Flushing: West is East', in *Sidewalk Critic: Lewis Mumford's Writings on New York*, ed. by Robert Wojtowicz (New York: Princeton Architectural Press, 1998), pp. 235-41

Patents

'Boat', Norman Bel Geddes, No. 91,579, United States, filed 1 November 1933 <https://patents.google.com/patent/USD91579S/en?oq=USD91579> [accessed 3 March 2018]

'Ship', Norman Bel Geddes, No. 2,141,180, United States, filed 28 August 1934 <https://patents.google.com/patent/US1958040A/en?oq=US1958040> [accessed 3 March 2018]

Secondary sources

Albrecht, Donald, 'Introduction', in *Norman Bel Geddes Designs America*, ed. by Donald Albrecht (New York: Abrams, 2012), pp. 11-53

Blaszczyk, Regina Lee, 'Imagining Consumers: Norman Bel Geddes and American Consumer Culture', in *Norman Bel Geddes Designs America*, ed. by Donald Albrecht (New York: Abrams, 2012), pp. 70-93

Brosterman, Norman, *Out of Time: Designs for the Twentieth-Century Future* (New York: Abrams, 2000)

Bush, Donald J., *The Streamlined Decade* (New York: George Braziller, 1975)

Cogdell, Christina, 'The Futurama Recontextualized: Norman Bel Geddes's Eugenic "World of Tomorrow"', *American Quarterly*, 52 (2000), 193-236

DiMento, Joseph F. C., and Cliff Ellis, *Changing Lanes: Visions and Histories of Urban Freeways* (Cambridge, MA: MIT Press, 2013)

Gorman, Carma R. 'Educating the Eye: Body Mechanics and Streamlining in the United States, 1925-1950', *American Quarterly*, 58 (2006), 839-68

Greif, Martin, *Depression Modern: The Thirties Style in America* (New York: Universe Books, 1975)

Hanks, David A., and Anne Hoy, *American Streamlined Design: The World of Tomorrow* (Paris: Flammarion, 2005)

Hillier, Bevis, and Kate McIntyre, *The Style of the Century*, 2nd edn (New York: Watson-Guptill, 1998)

Innes, Christopher, *Designing Modern America: Broadway to Main Street* (New Haven: Yale University Press, 2005)

------ 'Modular and Mobile', in *Norman Bel Geddes Designs America*, ed. by Donald Albrecht (New York: Abrams, 2012), pp. 200-13

Isenstadt, Sandy, 'The Future is Here: Norman Bel Geddes and the Theater of Time', in *Norman Bel Geddes Designs America*, ed. by Donald Albrecht (New York: Abrams, 2012), pp. 136-53

McDermott, Catherine, *Design: The Key Concepts* (Abingdon: Routledge, 2007)

McGuire, Laura, 'Theaters', in *Norman Bel Geddes Designs America*, ed. by Donald Albrecht (New York: Abrams, 2012), pp. 172-83

Maffei, Nicolas P., *Norman Bel Geddes: American Design Visionary* (London: Bloomsbury Academic, 2018)

Marchand, Roland, 'The Designers go to the Fair, II: Norman Bel Geddes, The General Motors "Futurama", and the Visit to the Factory Transformed', in *Design History: An Anthology*, ed. by Dennis P. Doordan (Cambridge, MA: MIT Press, 1995), pp. 103-21

Margolin, Victor, *World History of Design: Volume 2 World War I to World War II* (London: Bloomsbury Academic, 2015)

Meikle, Jeffrey L., '"A Few Years Ahead": Defining a Modernism with Popular Appeal', in *Norman Bel Geddes Designs America*, ed. by Donald Albrecht (New York: Abrams, 2012), pp. 114-35

Meikle, Jeffrey L., *Twentieth Century Limited: Industrial Design in America, 1925-1939* (Philadelphia: Temple University Press, 1979)

Morshed, Adnan, 'The Aesthetics of Ascension in Norman Bel Geddes's Futurama', *Journal of the Society of Architectural Historians*, 63 (2004), 74-99

Payne, Darwin Reid, *The Scenographic Imagination* (Carbondale: Southern Illinois University Press, 1981)

Schrenk, Lisa D., *Building a Century of Progress: The Architecture of Chicago's 1933 - 34 World's Fair* (Minneapolis: University of Minnesota Press, 2007)

Speck, Lawrence W., 'Futurama', in *Norman Bel Geddes Designs America*, ed. by Donald Albrecht (New York: Abrams, 2012), pp. 288-303

Szerlip, B. Alexandra, *The Man Who Designed the Future: Norman Bel Geddes and the Invention of Twentieth-Century America* (Brooklyn: Melville House, 2017)

Websites

Norman Bel Geddes Database, Harry Ransom Center, University of Texas at Austin <http://norman.hrc.utexas.edu/NBGPublic/> [accessed 23 February 2018]

Norman Bel Geddes Timeline, Harry Ransom Center, University of Texas at Austin, (2010) <http://www.hrc.utexas.edu/pressphotos/2012/nbg/pdf/Norman_Bel_Geddes_Timeline.pdf> [accessed 3 March 2018]

'The Liner of Tomorrow!', Pathé Pictorial, 7 March 1935 <https://www.britishpathe.com/video/the-liner-of-tomorrow/> [accessed 9 March 2018]

www.ingramcontent.com/pod-product-compliance
Lightning Source LLC
Chambersburg PA
CBHW070824220526
45466CB00002B/753